MW01352511

To Tony Tappe
who design beautiful sites
for books
best wishes
Elliot Paul Rothman

PAINTING ON SITE

Elliot Paul Rothman

BOSTON, MASSACHUSETTS
2004

PAINTING ON SITE
Elliot Paul Rothman

CREDITS:
Design: Leslie Anne Feagley
Photography: Clifford Pfeiffer

Copyright © 2003 by Elliot Paul Rothman

COVER: Hagia Sophia Interior, Istanbul, Turkey
I was struck by the invention in this space, by its color variations, and by the multiplicity of natural light sources. I sketched my attitude toward the interior, using graphite and transparent pigment that allowed the pencil work to show through. Perhaps my interior was brighter than when Justinian first built it, but the painting reflects the atmosphere of the place, as I sensed it.

FRONTISPIECE ONE: The Palace Hotel, Taroudant, Morocco
As you approach Taroudant, you are confronted by the massive pink stucco-faced wall of the ancient city which belies the variety of spaces within. The hotel where we stayed for several days was set just within the wall. Its series of terraces and courtyards mirrored the marvels of the ancient city structure.

FRONTISPIECE TWO: From Todi, Italy
The rolling Umbrian hills are Martha's favorite landscape. She always enjoys returning to this unspoiled region where she feels truly peaceful. I love the quilt-like organization of the fields with their contrasting forms and colors.

Library of Congress Cataloging-in-Publication Data

Rothman, Elliot Paul, 1935—

 Includes dedication, table of contents, foreword, introduction, index of paintings, about the artist, acknowledgements.
 Contents: Watercolors and crayon pastels painted on site by the artist in sixteen countries.

ISBN 0-615-12473-9 (hdbk.)
 1. Canada. 2. United States. 3. French West Indies. 4. Mexico. 5. Panama. 6. France. 7. Spain. 8. Morocco. 9. Italy. 10. Denmark. 11. Norway. 12. Sweden. 13. Turkey. 14. Israel. 15. Jordan. 16. China.
South China Printing Company Limited
 2003098702

Rothman Partners Architects, Inc.
711 Atlantic Avenue
Boston, MA 02111
www.rothmanpartners.com

The Palace Hotel, Taroudant, Morocco

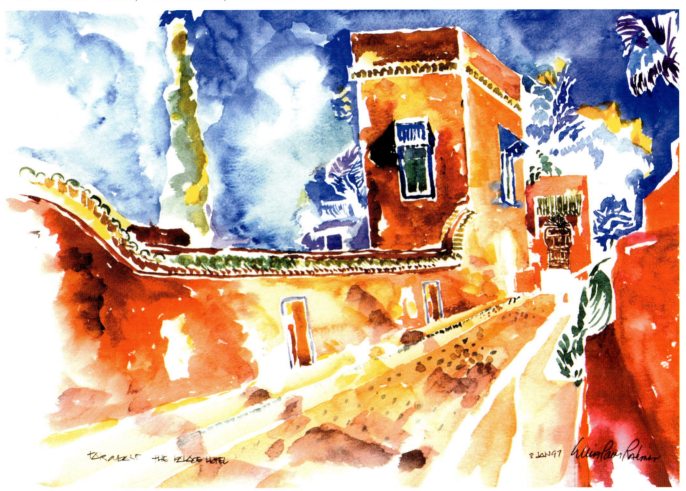

From Todi, Italy

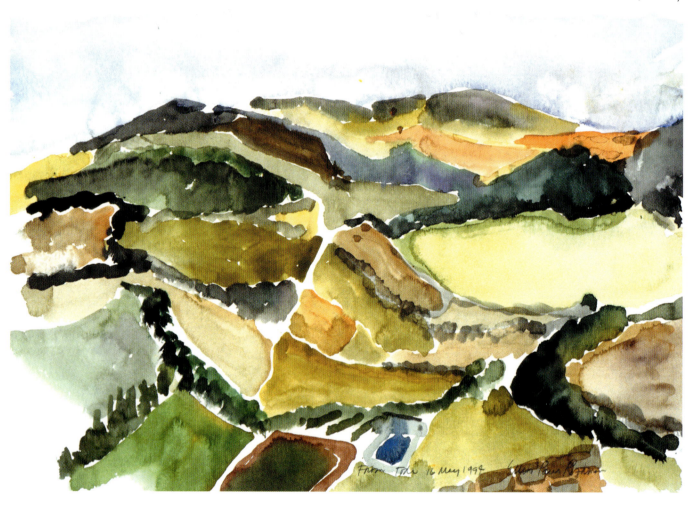

DEDICATION

PAINTING ON SITE
is dedicated to

Martha Leibowitz Rothman, FAIA,

Who planned and organized the travels we enjoyed together.
And to our children, Sabine, Adam, and Erik,
Who gave me the freedom to paint on family trips.

TABLE OF CONTENTS

FOREWORD .4
 by Donald Miller

INTRODUCTION .6
 by Elliot Paul Rothman

CANADA .8
 Canada Centre, Vancouver, 1998

UNITED STATES .9
 San Diego Marina, San Diego, 2002
 Marina, San Diego, 2002
 Marina from Hotel, San Diego, 2002
 Abyssinian Cat, Malibu, 2002
 Wellfleet Fishing Boats, Cape Cod, 1995
 Wellfleet Harbor, Cape Cod, 1995
 Newcomb Hollow, Wellfleet, 1996
 Audubon Lands, Wellfleet, 1990

FRENCH WEST INDIES17
 Gustavia, St. Barthélemy, 1995
 Ansé de Columbier, St. Barthélemy, 1995

MEXICO .19
 Plaza Promenade de la Luna, Teotihuacán, 2001
 Piramide del Sol, Teotihuacán, 2001

PANAMA .21
 Panama City, 1996
 Panama City Cathedral, 1996
 Kwadule, San Blas Islands, 1996
 Kwadule, San Blas Islands, 1996
 Parrot, San Blas Islands, 1996

FRANCE .26
 Pont Montebello, Paris, 1994
 Parc Andre Citroën, Paris, 1997
 Mont St. Michel, Normandy, 1997
 Le Château de Montmuran, Brittany, 1997
 Cantegrel, Dordogne, 2002
 Place de la Liberté, Sarlat, Dordogne, 2002
 Villa Savoye, Poissy, 2003

SPAIN .33
 Casa Mila/La Pedrera, Barcelona, 1999
 Cathedral at Barcelona, 1998
 Carousel, San Sebastian, 2002
 Guggenheim Museum, Bilbao, 2002

MOROCCO .37
 Fez, 1996
 From Hamoud El Majoub's Shop, Marrakech, 1997
 Dunes at Merzouga, 1996
 Essaouira, 1997
 From the Imperial Hotel, Marrakech, 1997

ITALY .42
 Duomo, Todi, 1994
 Piazza Collicola, Spoleto, 2003
 Monterossa, Cinque Terre, 1994
 Riomaggiore, Cinque Terre, 1994
 Manarola, Cinque Terre, 1994
 Molino di Celvie, Allerona, Umbria, 2003

DENMARK .48
 Copenhagen Waterfront, 1997
 Copenhagen Boat, 1997

NORWAY .50
 Trondheim, 1997
 Industrial Trondheim, 1997
 Buholmrasa, 1997
 The Norwegian Coast above the Arctic Circle, 1997
 Mountain Caves at Stokksund, 1997
 Svarttsen Glacier, 1997

SWEDEN .56
 Stockholm, 2000

TURKEY .57
 The Great Amphitheatre at Ephesus, 2001
 Curetas Way, Ephesus, 2001
 From Curetas Way to the Library of Celsus, 2001
 Hagia Sophia, Exterior, Istanbul, 2001
 Hagia Sophia, Close-up, 2001
 Hagia Sophia, Interior Sketch, 2001
 The Blue Mosque, Istanbul, 2001
 The Blue Mosque, 2001
 Courtyard of the Blue Mosque, 2001
 Spice Market, Istanbul, 2001
 Mosque from Latoon, 2001
 Looking at Aga Umam from Murat II, 2001
 Murat II, 2001
 Murat II Under Sail, 2001
 Kanus Hillside Tombs, 2001
 17th Century Byzantine Church, Gemiler Island, 2001
 Monaster Isle, 2001
 Kalkan, 2001

ISRAEL .75
 Jaffa from Tel-Aviv, 2000

JORDAN .76
 Al Kazneh – The Treasury Building, Petra, 2000
 Nabataen Tombs, Petra, 2000

CHINA .78
 Pagoda Pond, Peking University, 1994
 Lotus Pond, Peking University, 1994
 The Forbidden City, Beijing, 1994
 The Summer Palace, Beijing, 1994

INDEX OF PAINTINGS82

ABOUT THE ARTIST94

ACKNOWLEDGEMENTS95

CONCLUSION .96

FOREWORD

The Artist On Site

Elliot Paul Rothman first approached watercolor at Taylor Allderdice High School in Pittsburgh, Pennsylvania, long before he became one of Boston's most distinguished architects. In our high school art class we both labored on traffic safety posters for a boring contest when, to paraphrase Gustave Flaubert in *Madame Bovary*, we longed to move the stars. Elliot would have his share of that.

In 1953-1954 in his freshman year, Elliot studied art and architecture at Carnegie Mellon University, then Carnegie Institute of Technology. He would learn and test many ideas from his energetic watercolor teacher Raymond Simboli.

While studying city planning at Harvard University's Graduate School of Design, Elliot traveled around northern New England with his class. Instead of annotating the trip with text, normal for the class, he produced a sketch report, later learning to submit written reports.

From 1975 he was influenced by M. Murray Leibowitz, his late father-in-law, an architect and artist who studied at Carnegie Tech, Columbia University, and Fontainebleau in the 1920s.

But no one, not even Elliot, knew he was laying the foundation for his vibrant paintings that would resurface, beginning in 1980, during his world travels. He presents many of these works for the first time in this handsome book and discusses here how his images came to be.

Today Elliot Paul Rothman paints wherever he travels. The paintings are personal creations but explore major themes of some of the world's greatest buildings.

This duality characterizes how Elliot Paul Rothman's mind easily bridges the worlds of painting and architecture. As an architect, he chairs and helps to guide his own firm with his architect wife, Martha, the firm's president. They have three children, Sabine, Adam, and Erik.

Among Elliot Paul Rothman's desires as an artist is to

paint more scenes of Boston, where he lives and dreams. He would also like to publish a series of continuous scenes done on a boat trip up the Nile River, reliving in a sense the 1838 Egyptian journey of the painter David Roberts (1796–1864).

How should we characterize Elliot Paul Rothman's work as a watercolorist? His paintings have the spark and spontaneity of John Marin (1870-1953) with the color sensitivity of Charles Demuth (1883-1935), both American masters of twentieth century art. Yet Elliot possesses his own aqueous style blending looseness and firmness, sketchiness and delineation. His profound understanding of three-dimensional structures allows him to paint often without prior sketching. Clearly his strong productions are romantically stimulated by impressive locations. It is less obvious that he almost always works outdoors, not without attendant natural problems.

It is not often that a writer can critique the paintings of a friend he knew in high school and summarize it with full praise when gathered in a book. But this is one of those occasions. I hope the reader will also find many special moments while enjoying the bold creations of Elliot Paul Rothman.

— DONALD MILLER

Author of six books on artists and architects, Donald Miller writes for the Naples Daily News. *He was, until retirement after forty-three years, the art and architecture critic of the* Pittsburgh Post-Gazette.

INTRODUCTION

Architects have traveled around the world sketching for centuries. It was part of our traditional education to document the world's great buildings. Today, some architects use the camera to record their travels. I am in the more traditional category, painting with watercolors on paper and drawing in sketchbooks to chronicle mine.

Why draw or paint? The process helps us learn to understand proportion, form, and scale. More important, when I paint and draw, I am not just seeing but feeling, not just describing but interpreting, not just depicting a place but marking my own presence. I am expressing my own experience. I am creating my own memories.

When I arrive at a site where I will paint, my heart starts beating faster. I feel a sense of elation. I feel a rush of adrenaline. There is joy in arriving in a space that is perfectly scaled for people, with all the visual variety that flows from human activity. I am drawn to places where I can situate myself within the scene. These are the places that elevate my spirit.

I have a backpack organized with all of my supplies—paper, brushes, paint tubes, and bottles of water. I sit down, spread out my tools, and initiate the work. It doesn't always go smoothly. I was thrown out of Saint Chapelle in Paris when my water overflowed on the floor, and from the Majorelle gardens in Marrakech for no apparent reason, as far as I could tell. More often, I am left to sit and paint for hours at a time. I sit all day sometimes and the space reveals its layers. The process also yields other personal rewards—more than I could ever expect. People stop to see what I am up to. My family checks in periodically. Often, children come to watch me and I give them a pad and brush so that they can paint with me. This was especially true in China. My hand, my activity, and my continuing presence connect me to the places and the people.

Sometimes, I find an ordinary space that seems like a comfortable place to sit and paint. It does not have to be memorable. I don't have to go looking for a Bilbao; I need not find a Hagia Sofia every time. As I paint, I see the magic in the scene. It elicits my excitement. I begin to make sense of the composition, so it becomes part of my own experience. When I paint a hillside, for example, I see all of the mass, then fields emerge, houses emerge, cows emerge, and people emerge. The more I look at a site, the more I realize its detail and depths.

Themes that continue to fascinate me include landscape, gathering crowds, architecture, water, and boats. Most of all, I paint and draw what I see when I see it. I arrive, sit down, begin and complete the work, and move on. I never modify or enhance the painting in a studio. It is what it is. I hope the immediacy of the paintings reflects the joy, passion, and pure fun of my adventure.

— ELLIOT PAUL ROTHMAN

Canada Centre, Vancouver

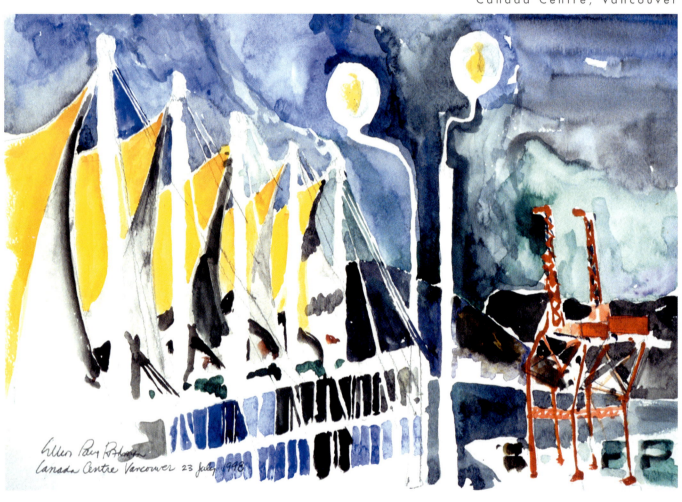

8 CANADA

San Diego Marina, San Diego

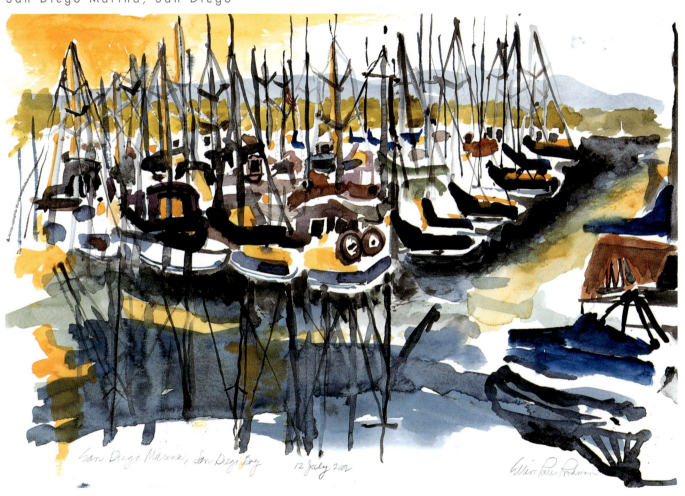

UNITED STATES 9

Marina, San Diego

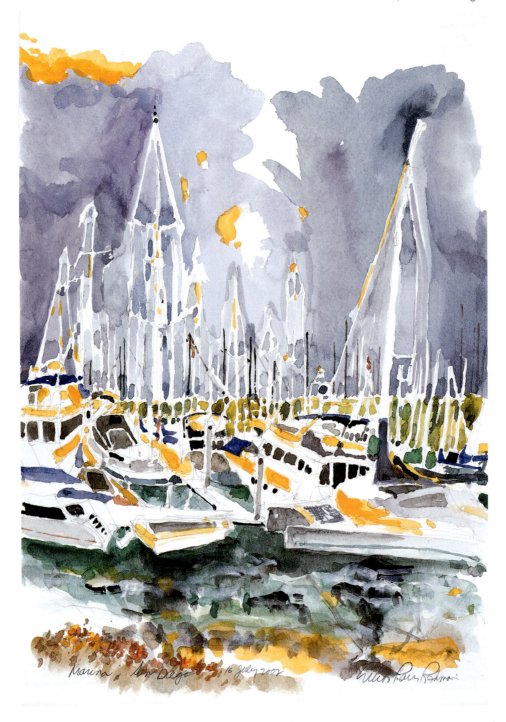

Marina from Hotel, San Diego

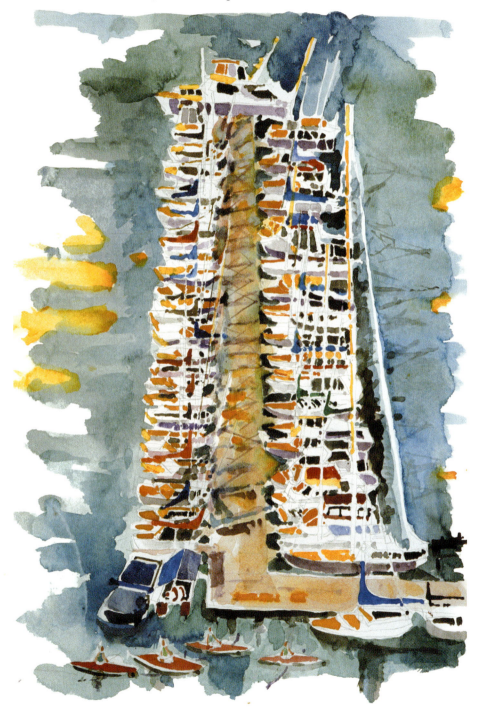

UNITED STATES 11

Abyssinian Cat, Malibu

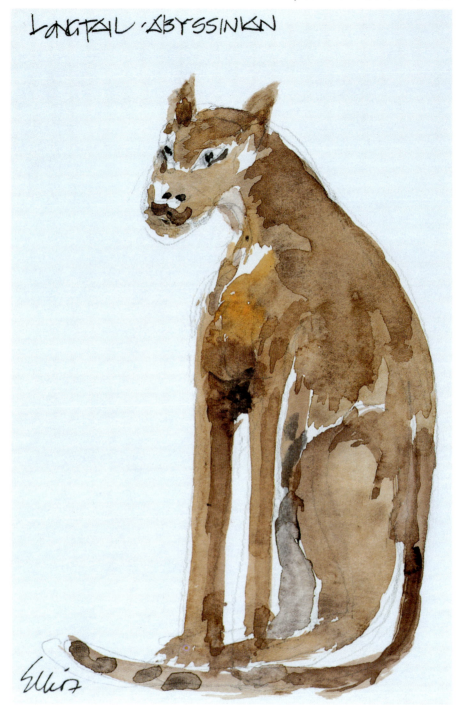

Wellfleet Fishing Boats, Cape Cod

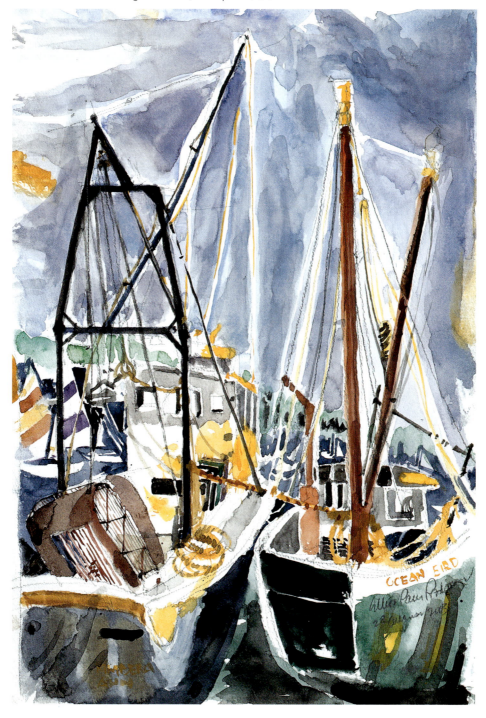

Wellfleet Harbor, Cape Cod

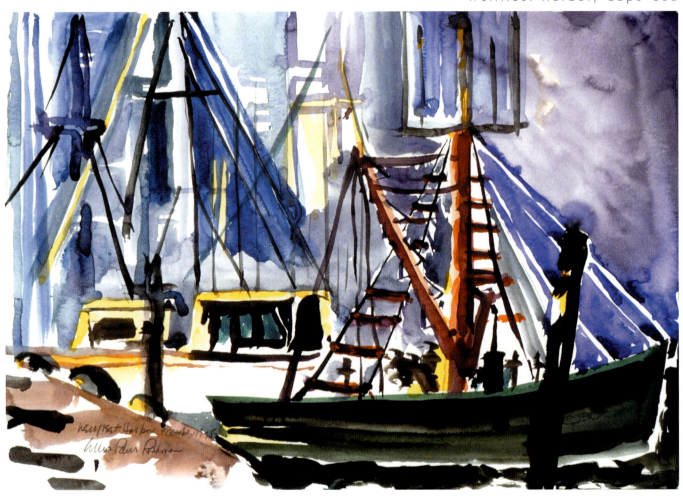

14 UNITED STATES

Newcomb Hollow, Wellfleet

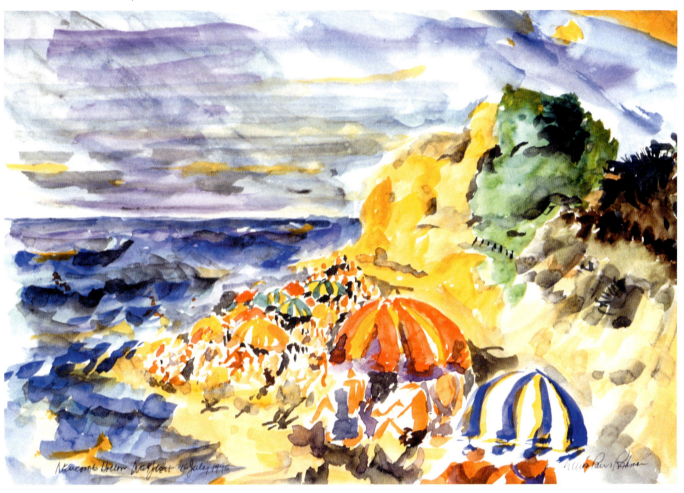

UNITED STATES

Audubon Lands, Wellfleet

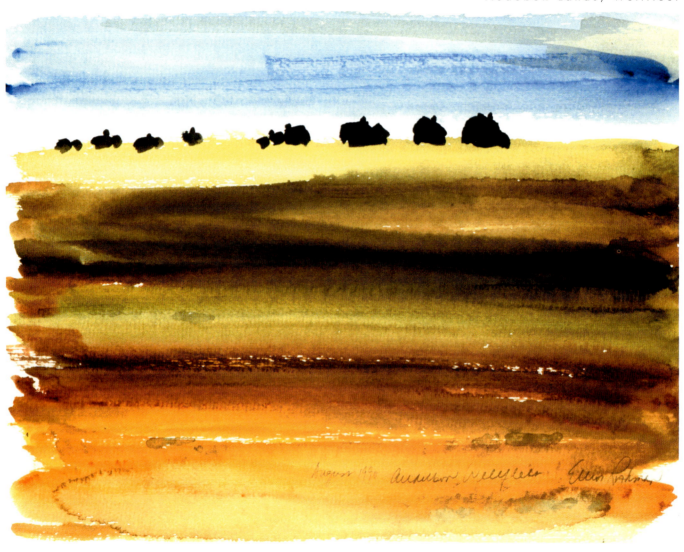

Gustavia, St. Barthélemy

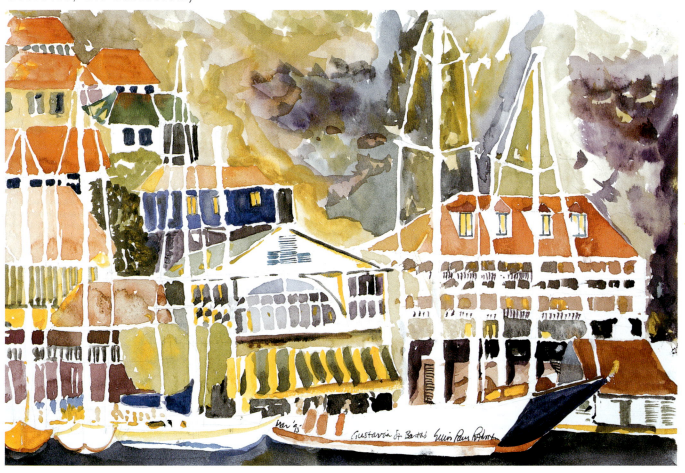

FRENCH WEST INDIES

Ansé de Columbier, St. Barthélemy

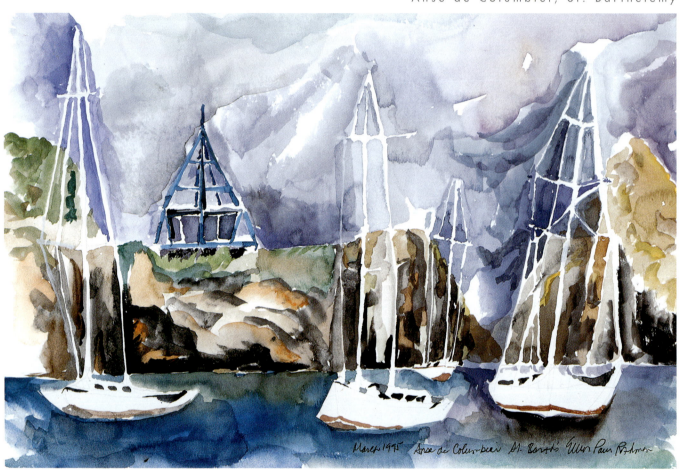

Plaza Promenade de la Luna, Teotihuacán

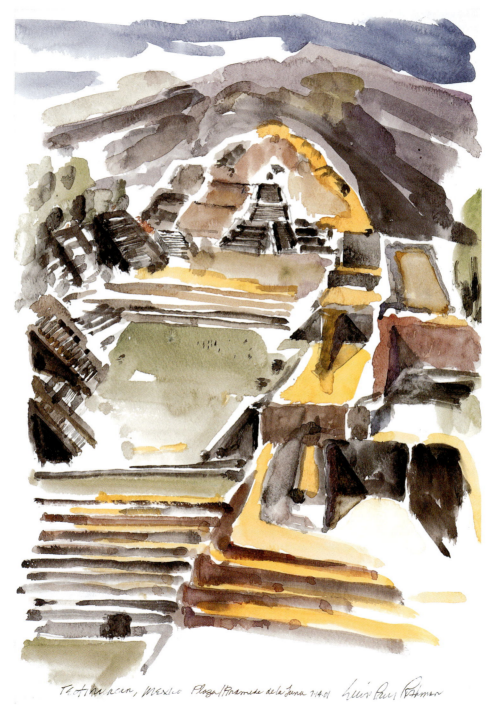

MEXICO

Piramide del Sol, Teotihuacán

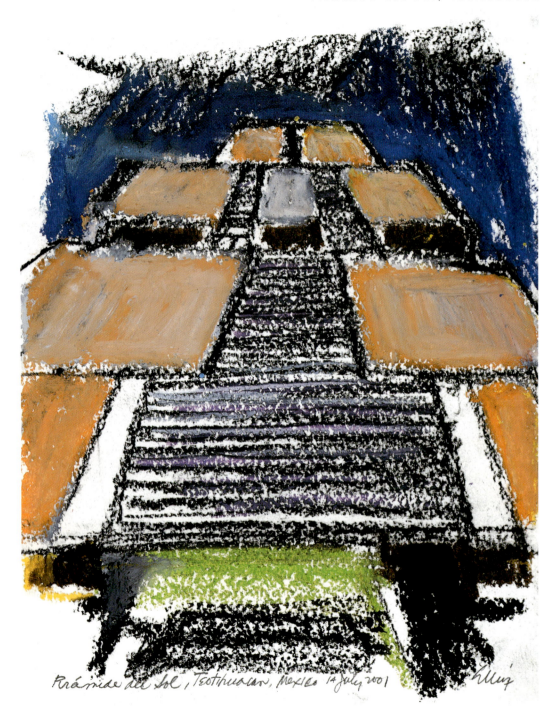

MEXICO

Panama City

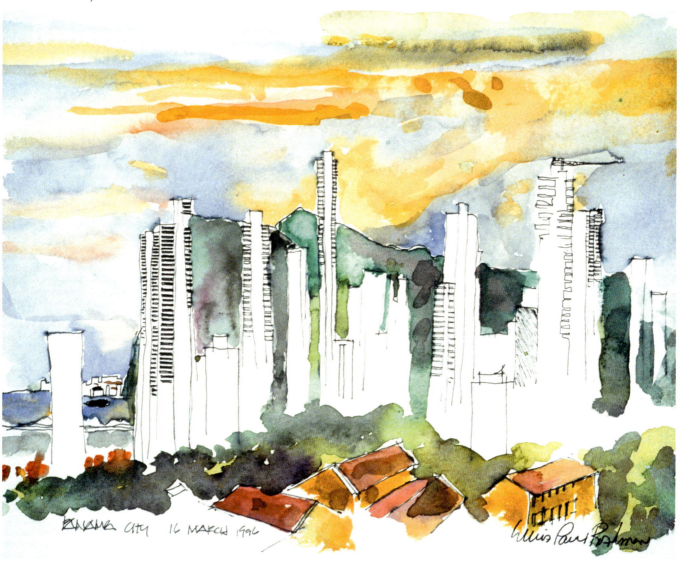

PANAMA 21

Panama City Cathedral

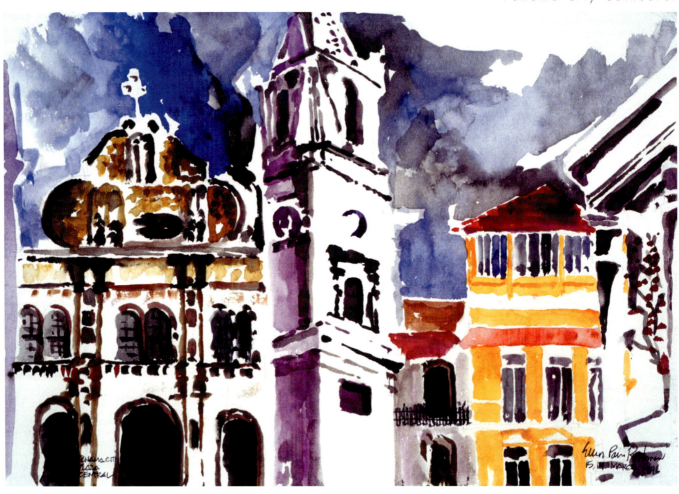

Kwadule, San Blas Islands

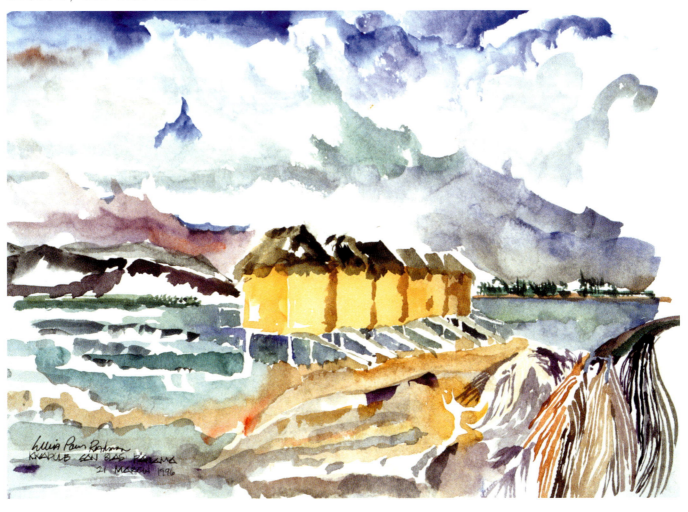

PANAMA

Kwadule, San Blas Islands

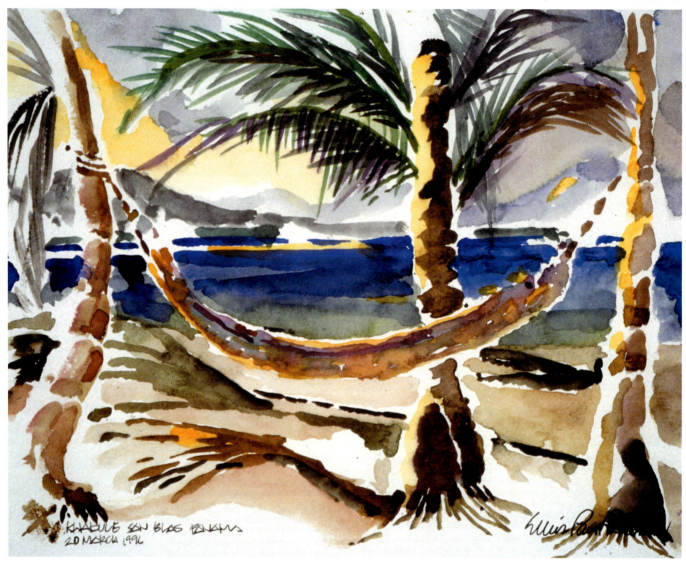

Parrot, San Blas Islands

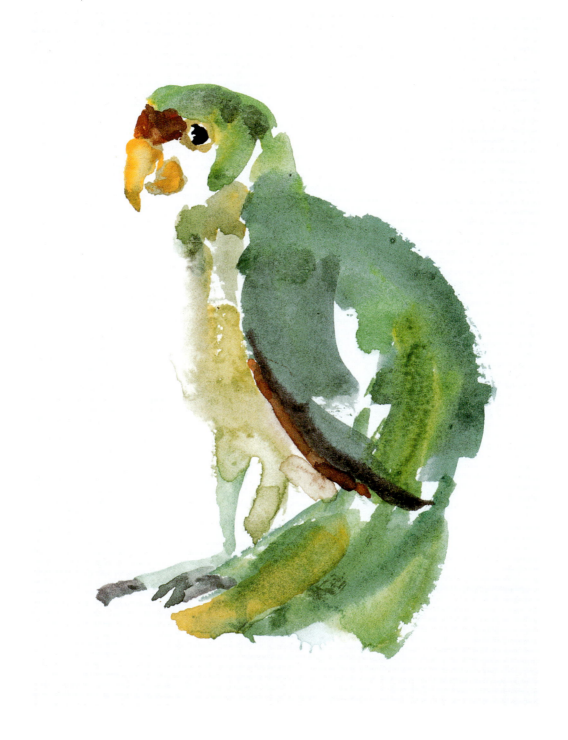

PANAMA

Pont Montebello, Paris

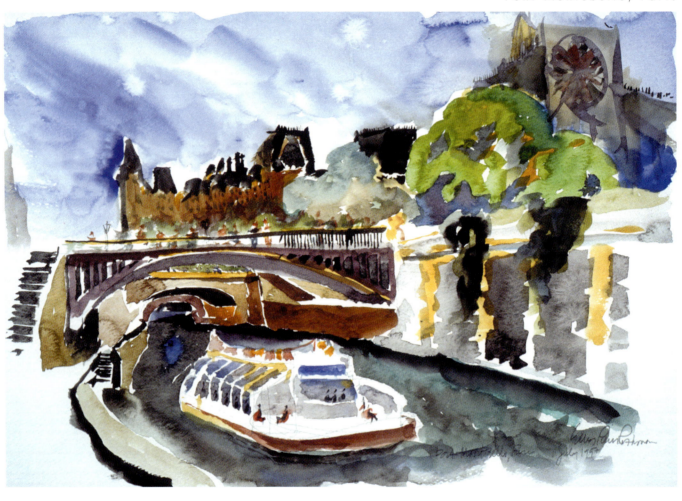

FRANCE

Parc Andre Citroën, Paris

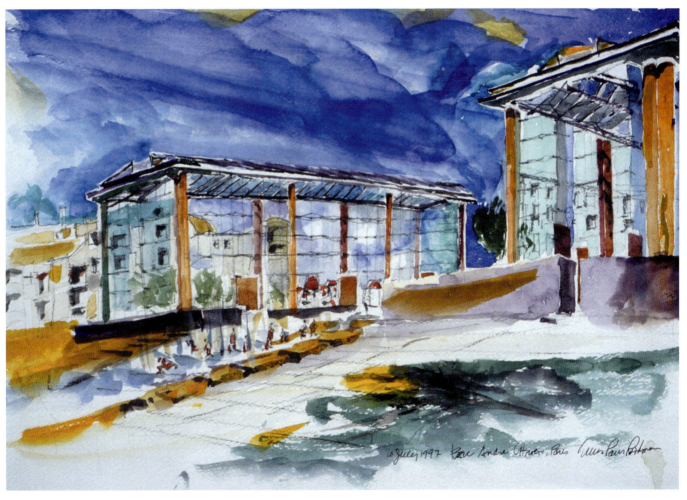

FRANCE

Mont St. Michel, Normandy

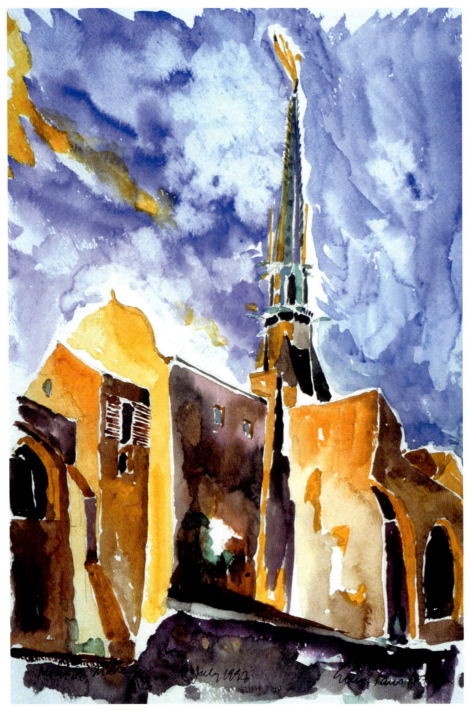

FRANCE

Le Château de Montmuran, Brittany

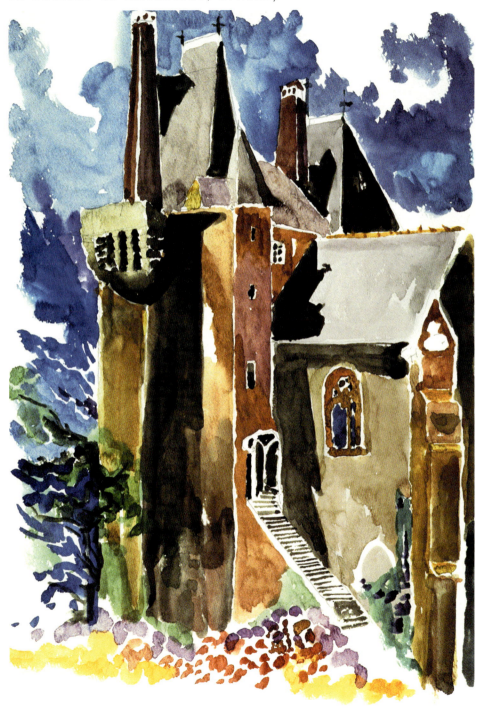

FRANCE

Cantegrel, Dordogne

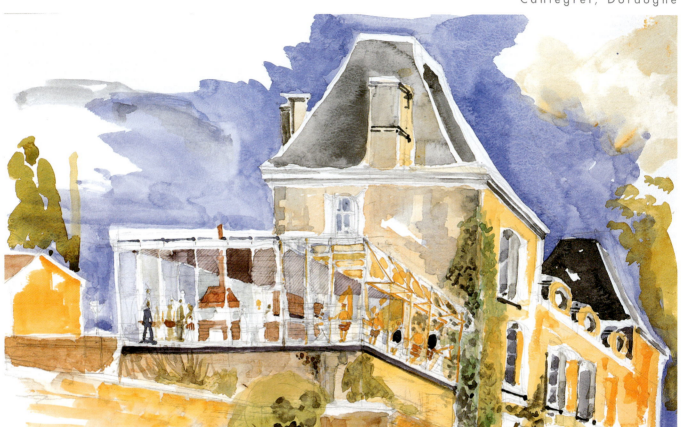

Place de la Liberté, Sarlat, Dordogne

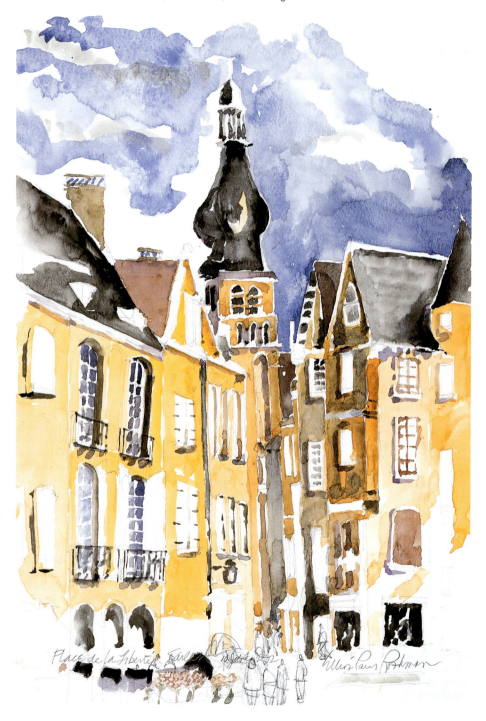

FRANCE

Villa Savoye, Poissy

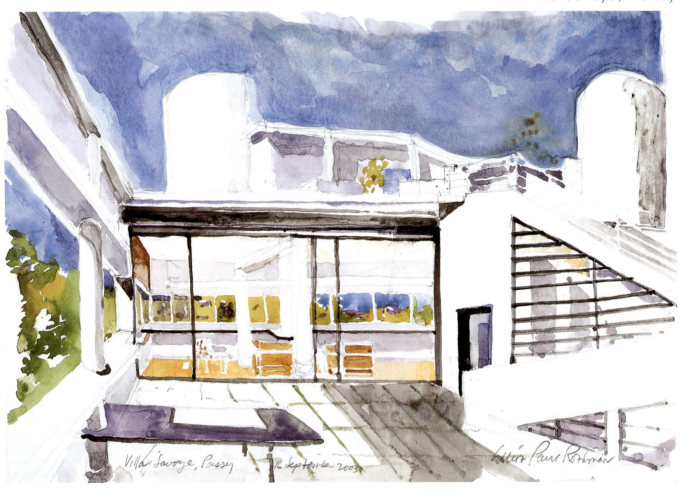

32 FRANCE

Casa Mila/La Pedrera, Barcelona

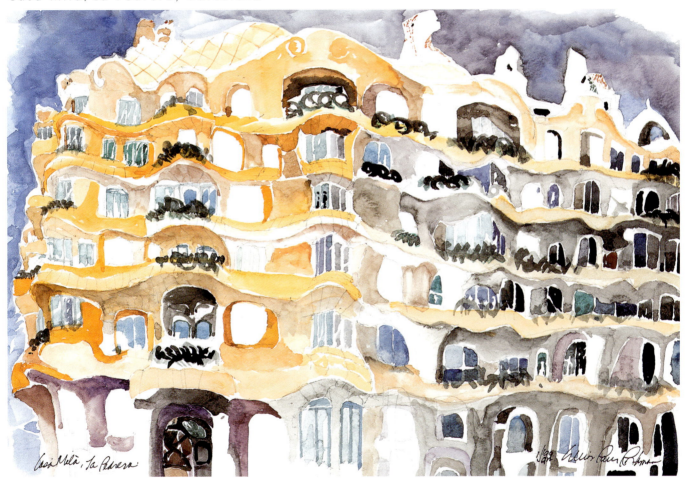

SPAIN

Cathedral at Barcelona

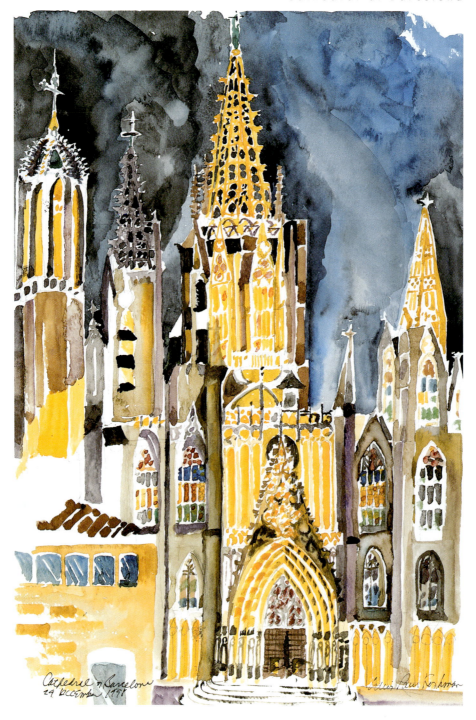

Carousel, San Sebastian

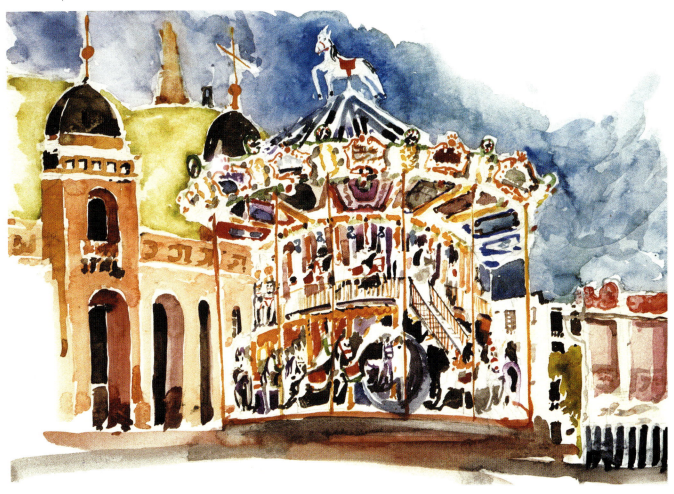

SPAIN 35

Guggenheim Museum, Bilbao

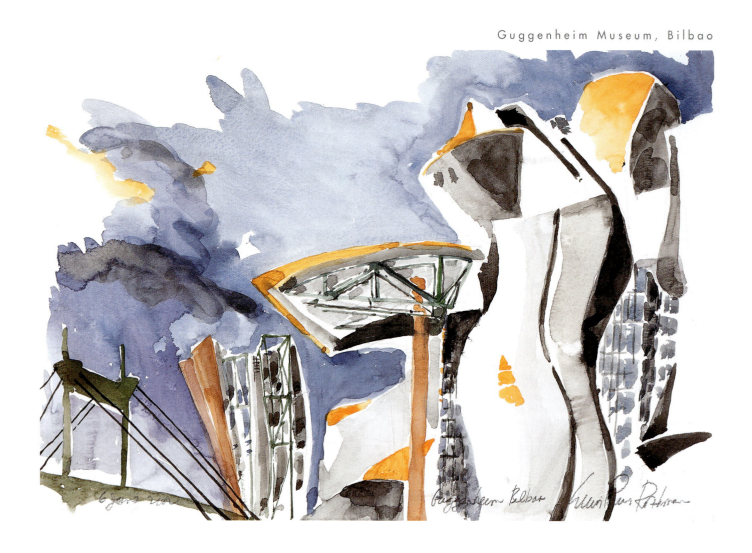

Fez

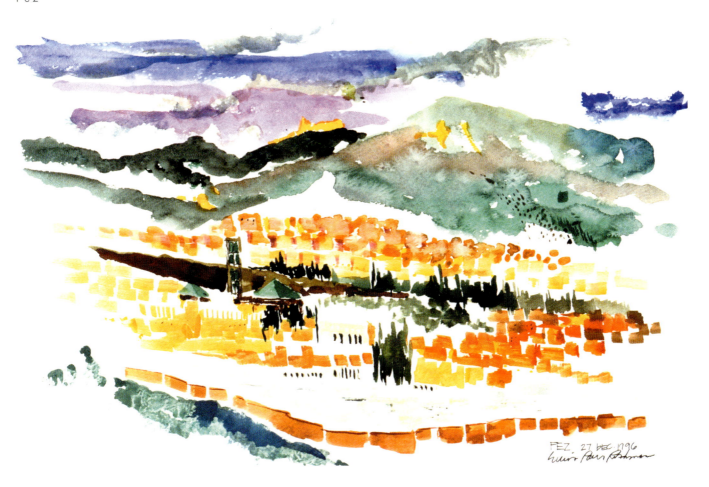

MOROCCO

From Hamoud El Majoub's Shop, Marrakech

38 MOROCCO

Dunes at Merzouga

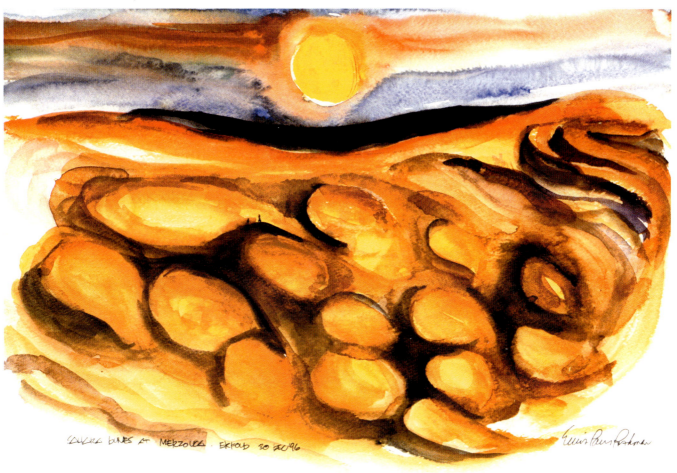

MOROCCO

Essaouira

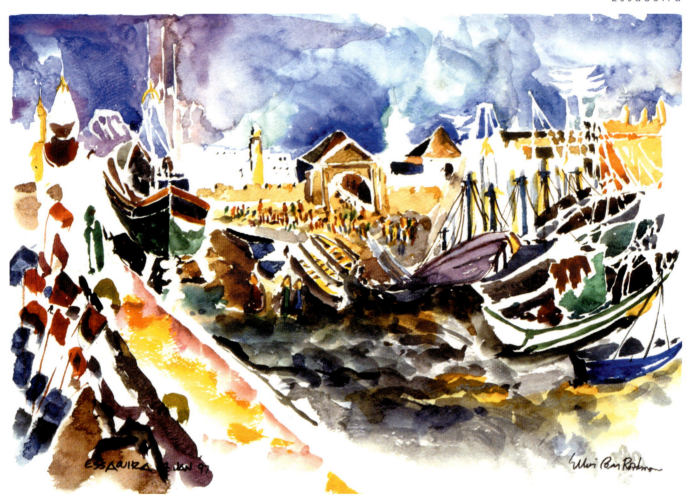

From The Hotel Imperial, Marrakech

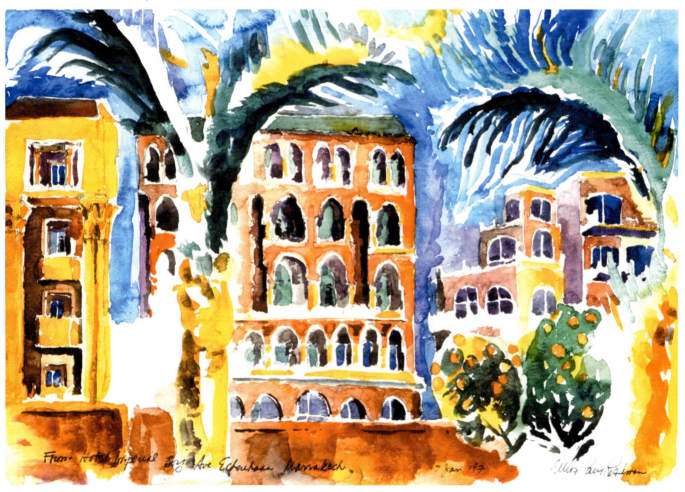

MOROCCO

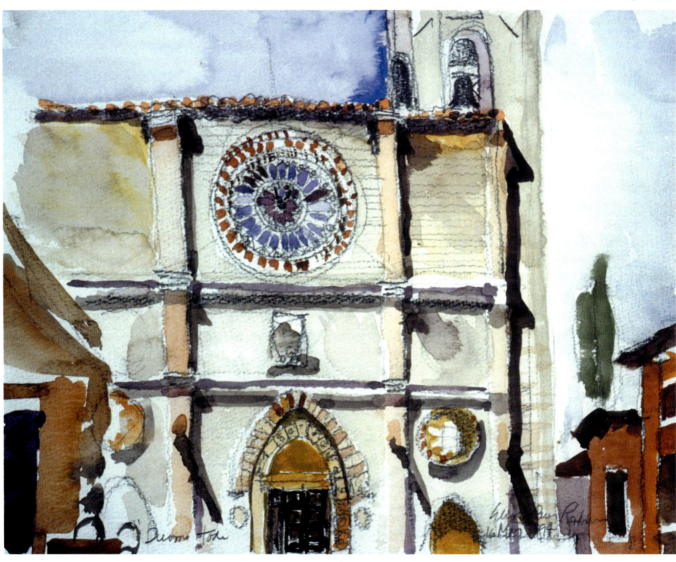

Duomo, Todi

Piazza Collicola, Spoleto

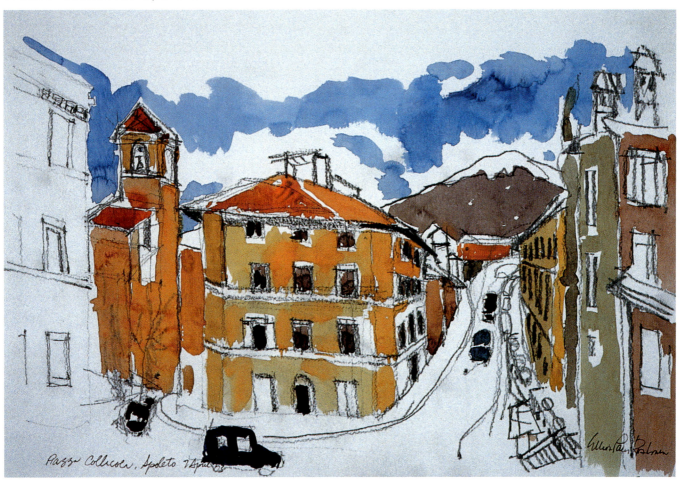

ITALY

Monterossa, Cinque Terre

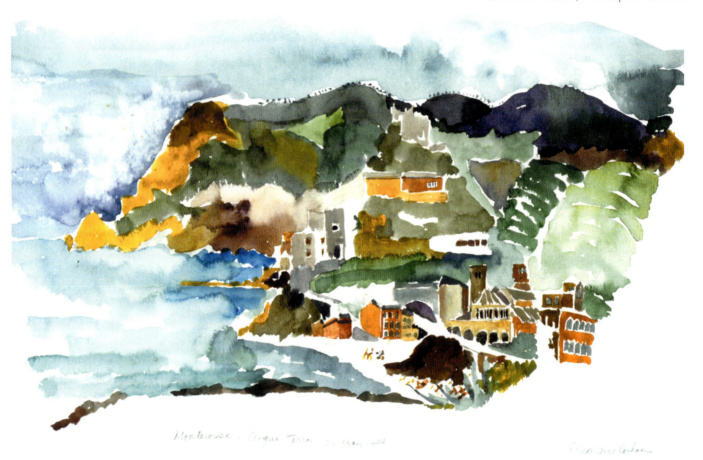

ITALY

Riomaggiore, Cinque Terre

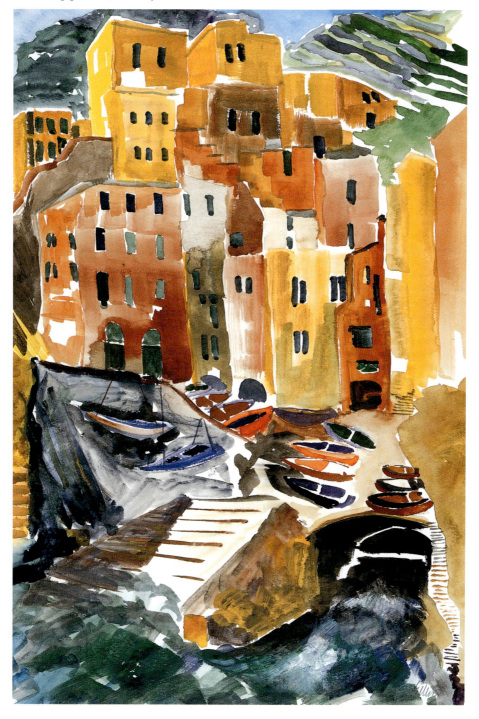

Manarola, Cinque Terre

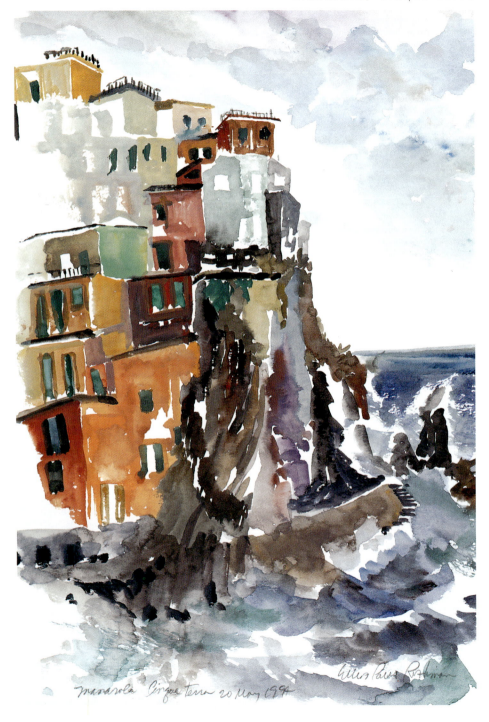

ITALY

Molino di Celvie, Allerona, Umbria

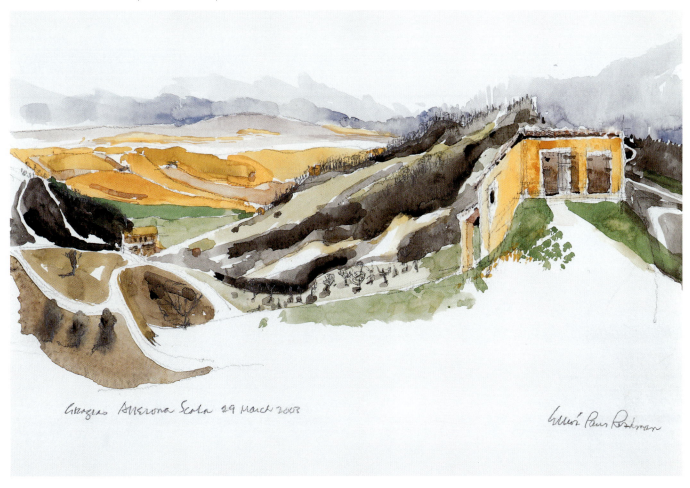

ITALY

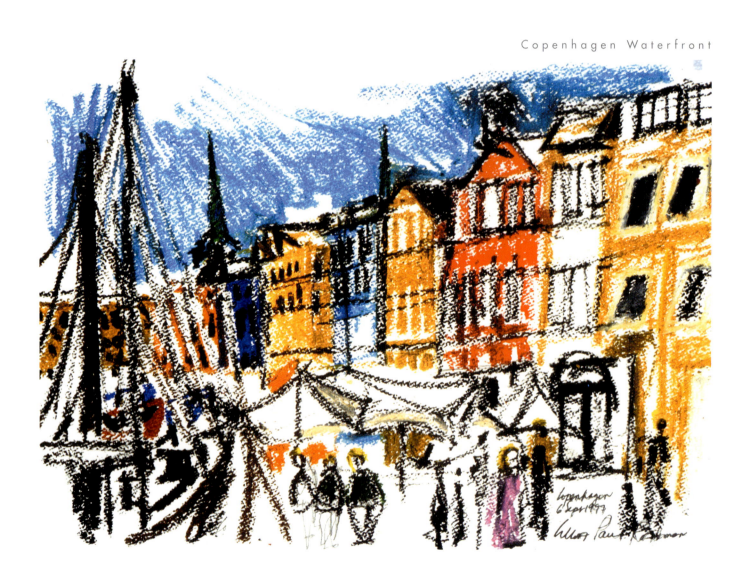

Copenhagen Waterfront

Copenhagen Boat

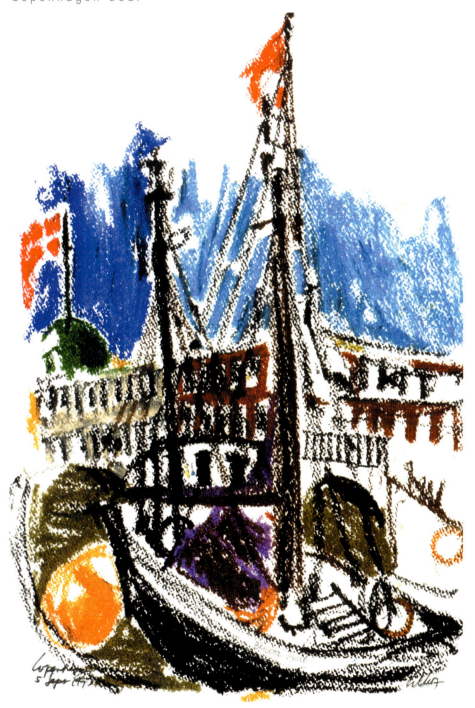

DENMARK 49

Trondheim

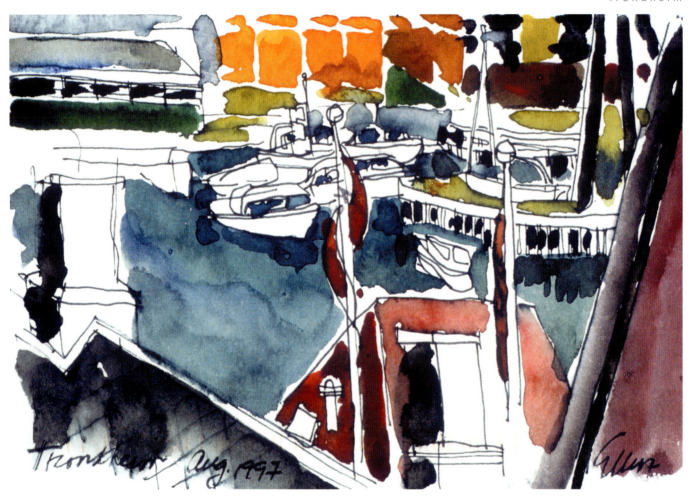

NORWAY

Industrial Trondheim

NORWAY 51

Buholmrasa

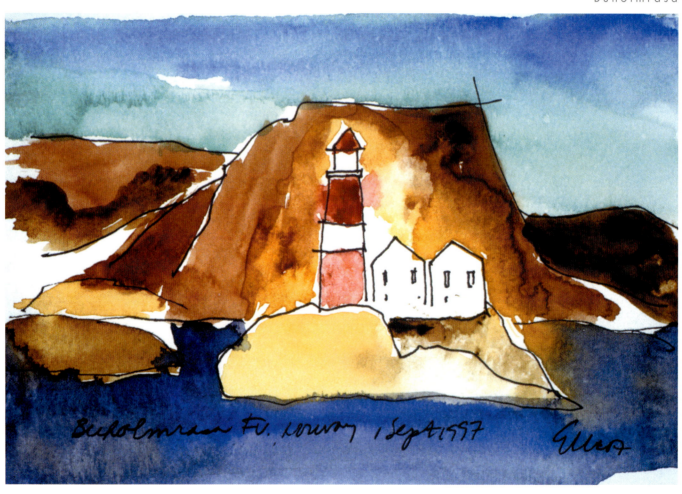

The Norwegian Coast above the Arctic Circle

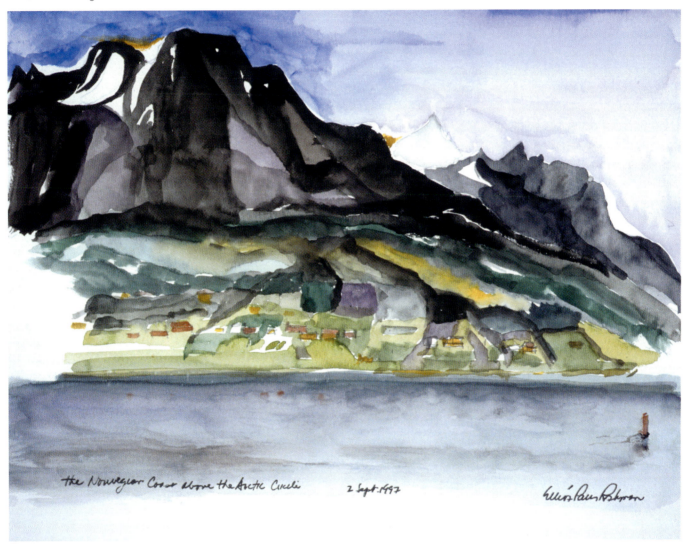

NORWAY

Mountain Caves at Stokksund

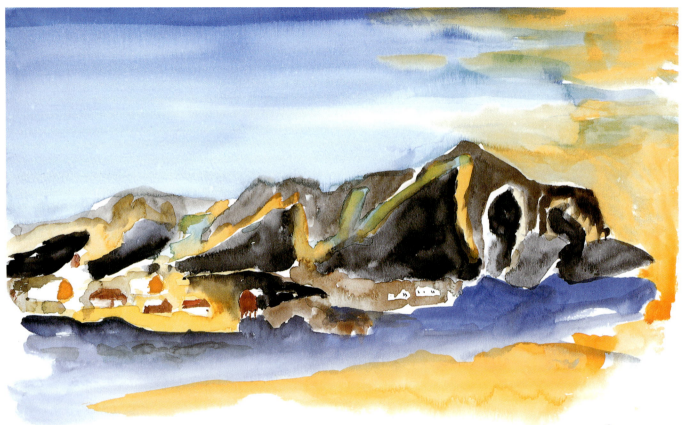

54 NORWAY

Svarttsen Glacier

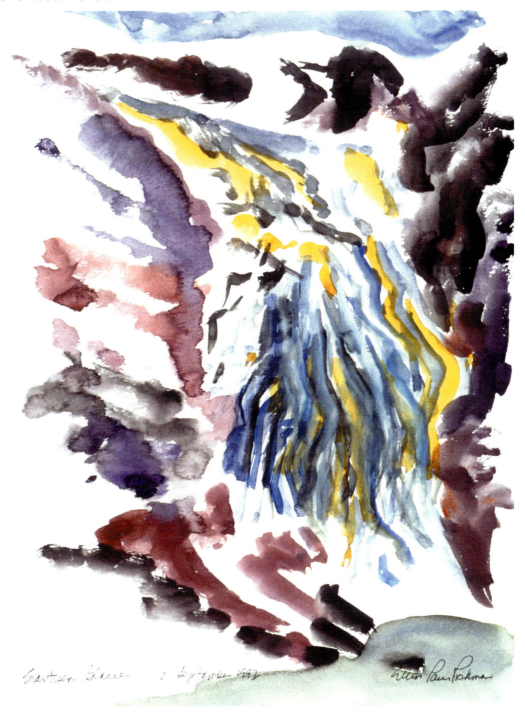

NORWAY

Stockholm

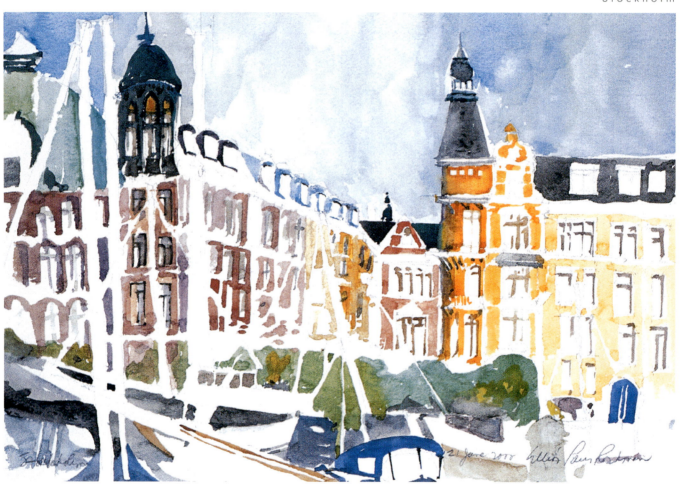

SWEDEN

The Great Amphitheatre at Ephesus

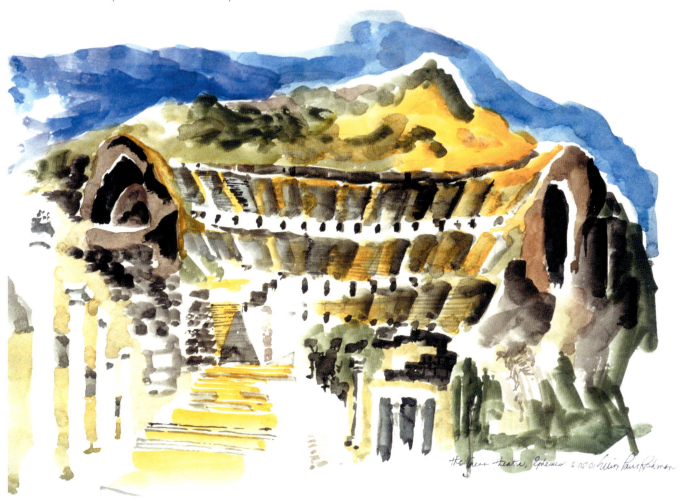

TURKEY 57

Curetas Way, Ephesus

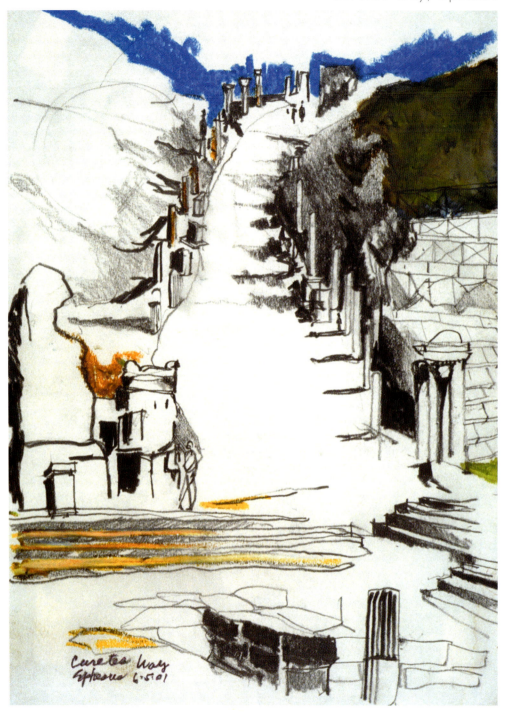

TURKEY

From Curetas Way to the Library of Celsus

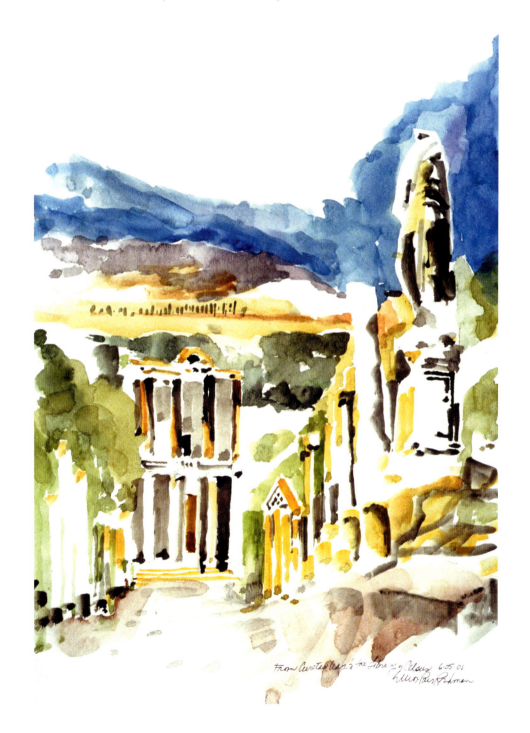

TURKEY

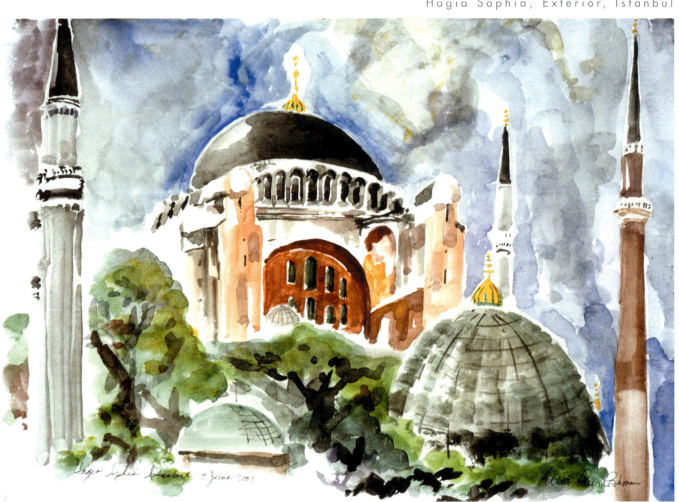

Hagia Sophia, Exterior, Istanbul

TURKEY

Hagia Sophia (Close-up), Istanbul

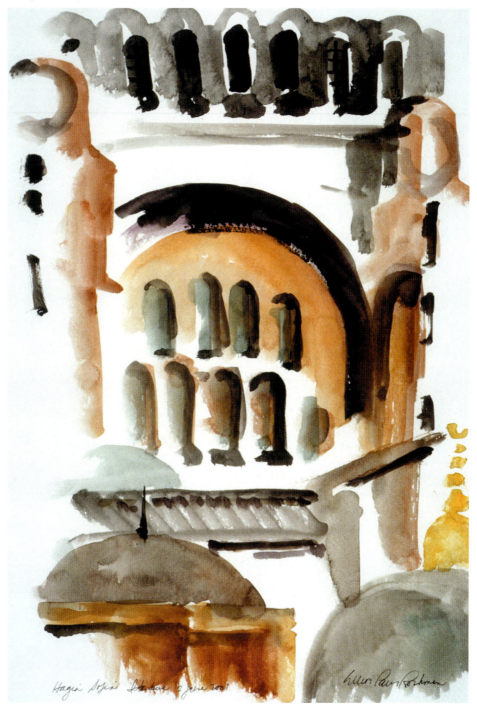

TURKEY

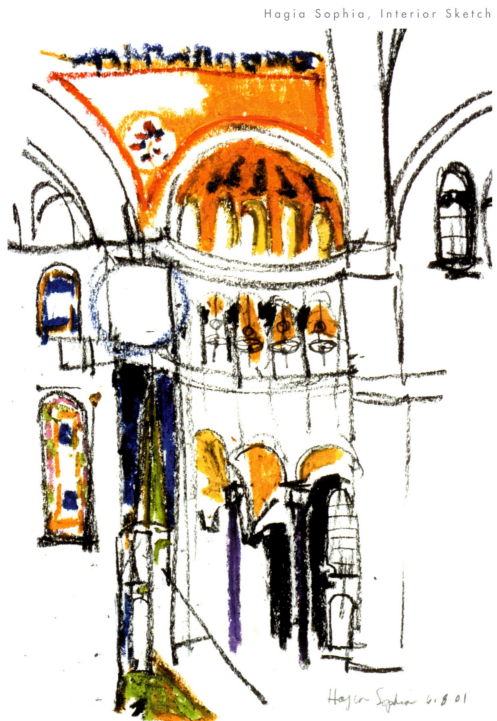

Hagia Sophia, Interior Sketch

The Blue Mosque, Istanbul

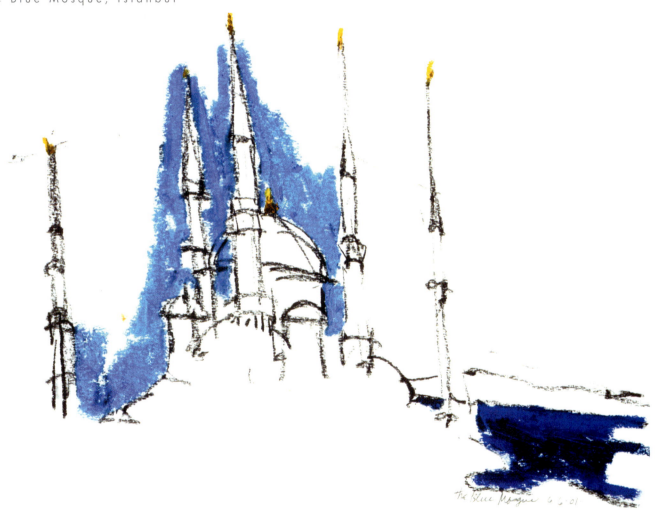

TURKEY 63

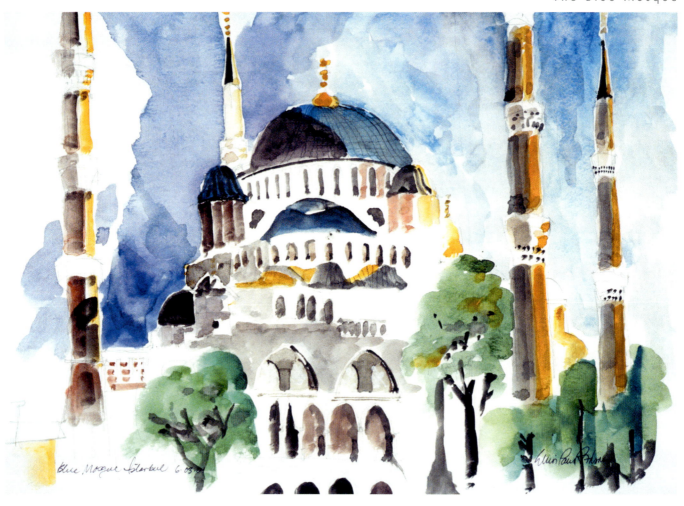

The Blue Mosque

64 TURKEY

Courtyard of the Blue Mosque

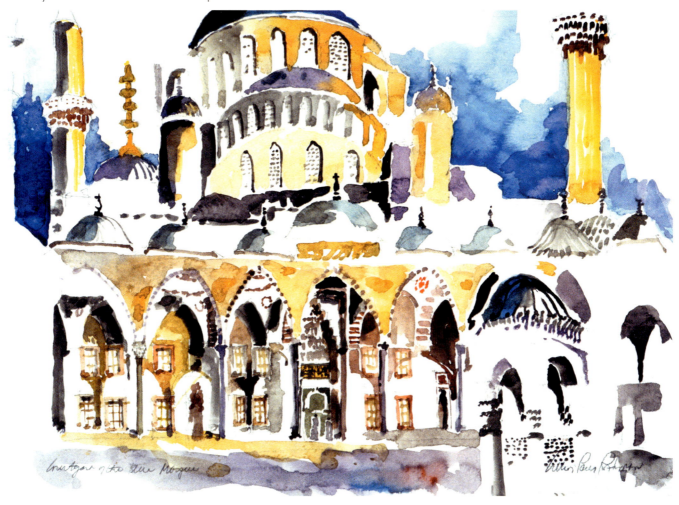

TURKEY

Spice Market, Istanbul

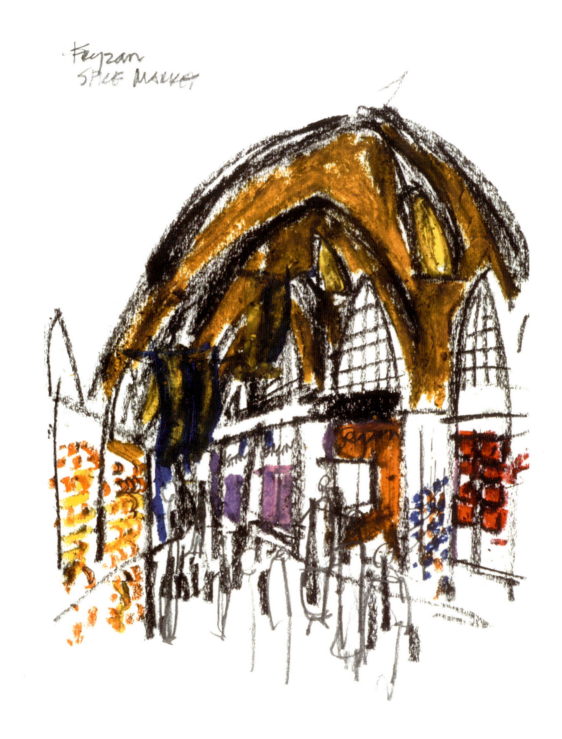

66 TURKEY

Mosque from Latoon

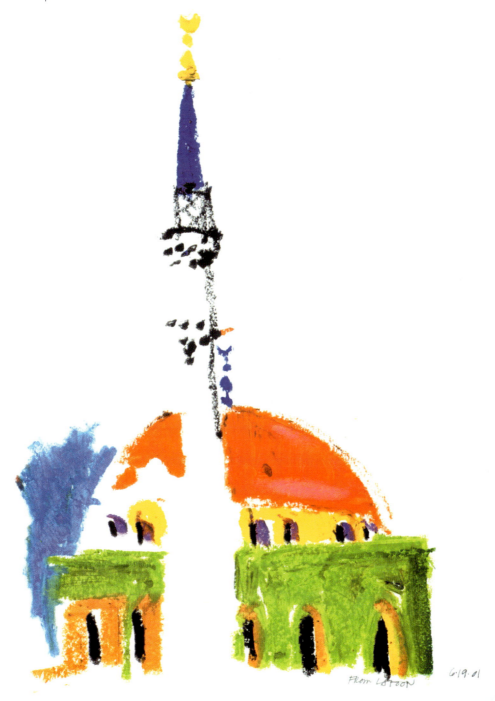

TURKEY

Looking at Aga Umam from Murat II

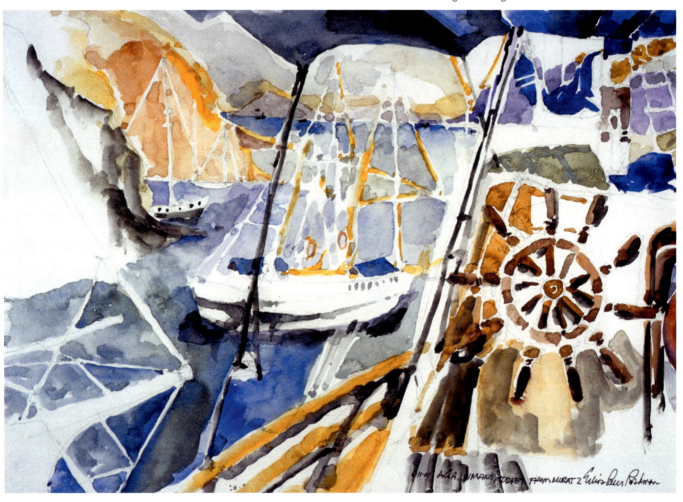

TURKEY

Murat II

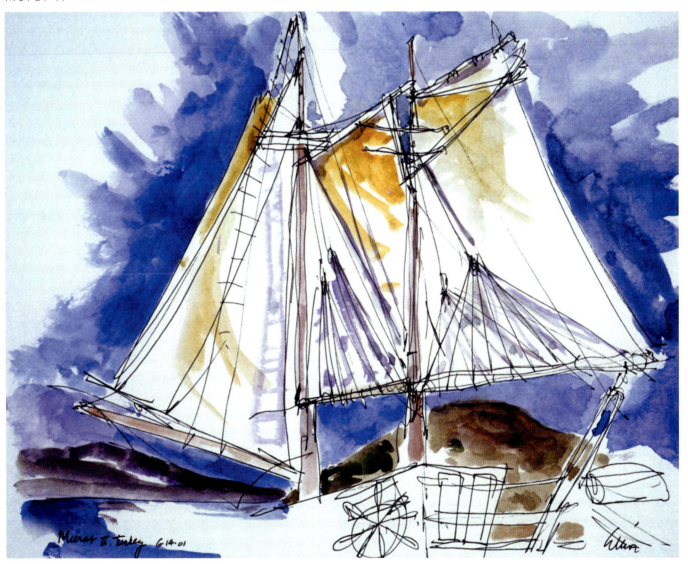

Murat II Under Sail

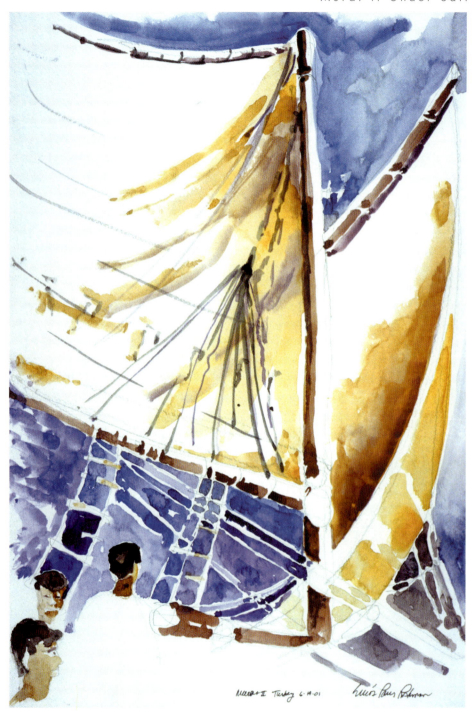

Kanus Hillside Tombs

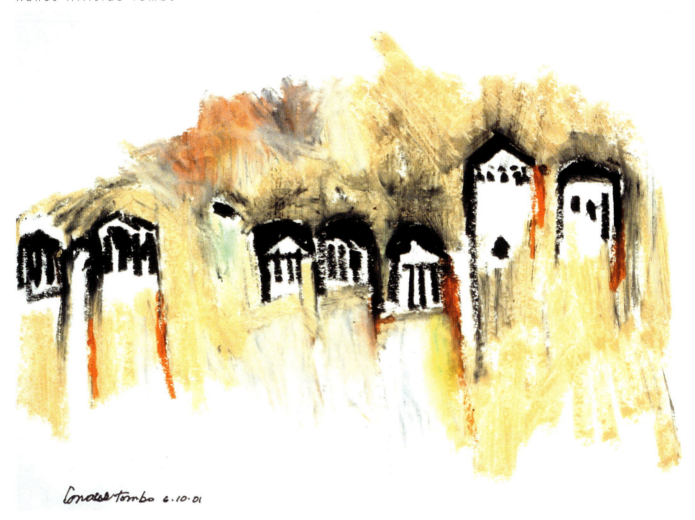

TURKEY 71

17th Century Byzantine Church, Gemiler Island

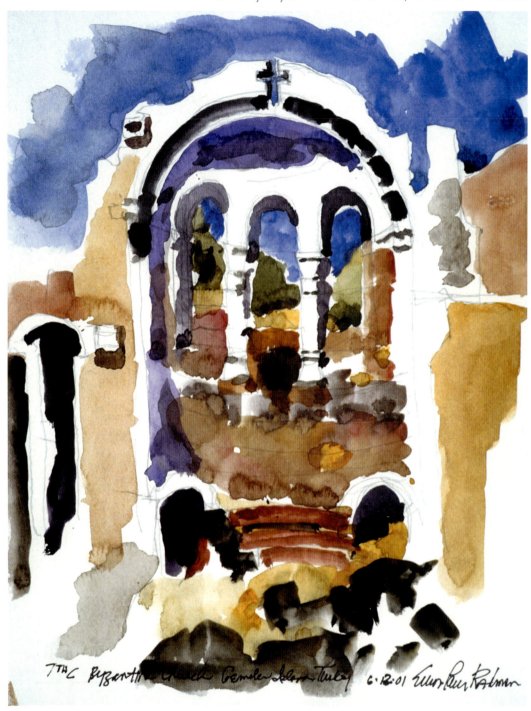

TURKEY

Monaster Isle

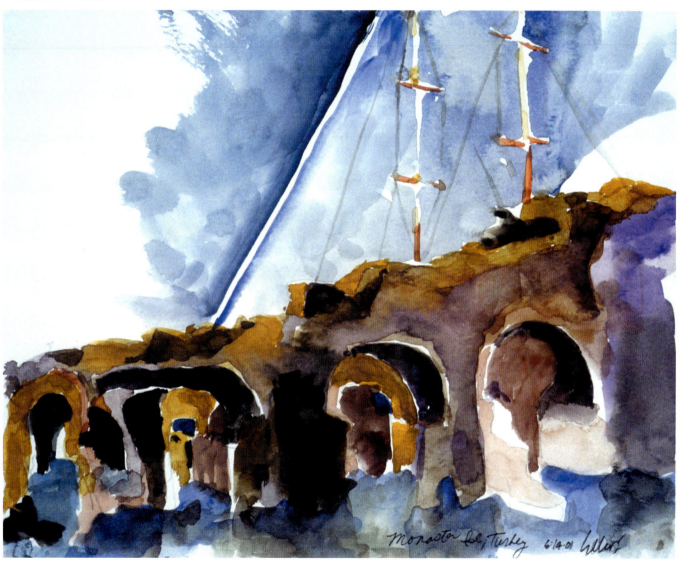

TURKEY

Kalkan

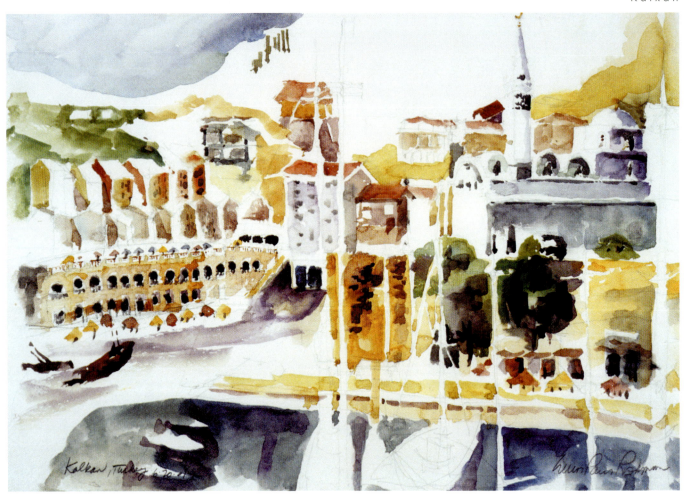

Jaffa from Tel-Aviv

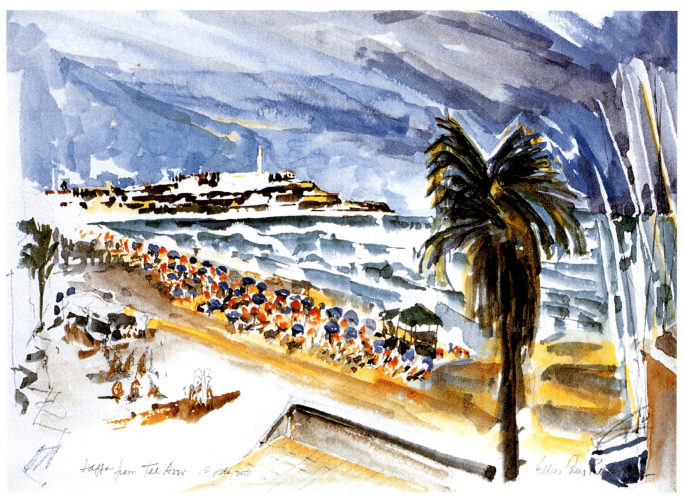

ISRAEL 75

Al Kazneh – The Treasury Building, Petra

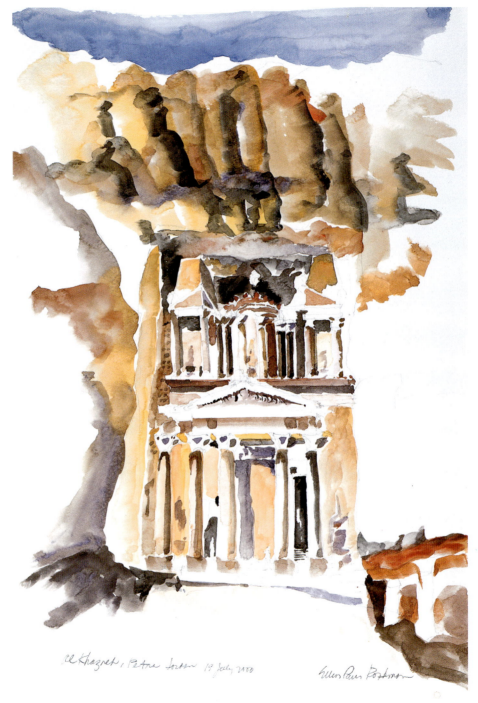

Nabataen Tombs, Petra

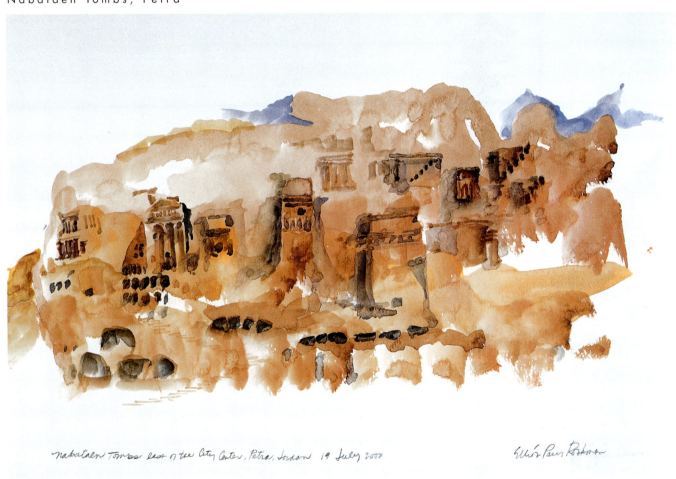

JORDAN

Pagoda Pond, Peking University

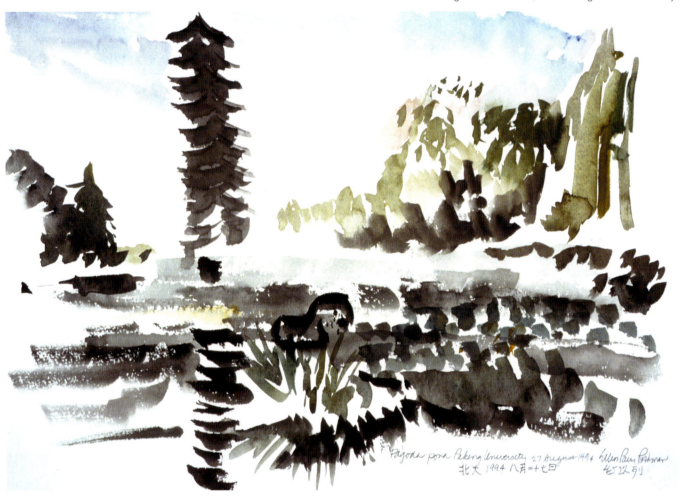

Lotus Pond, Peking University

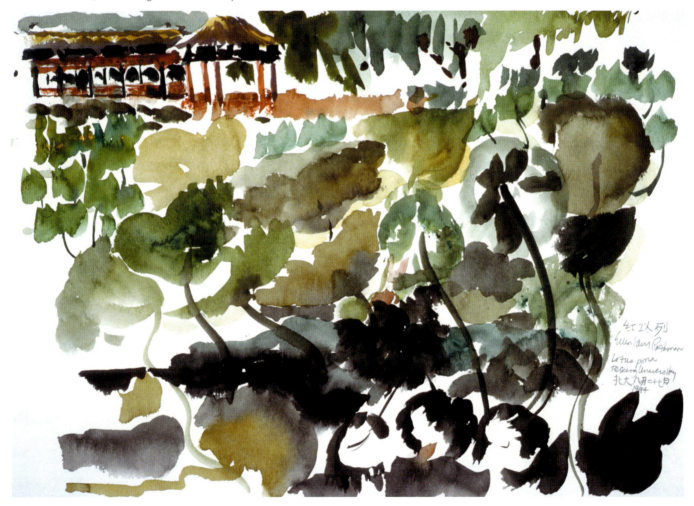

The Forbidden City, Beijing

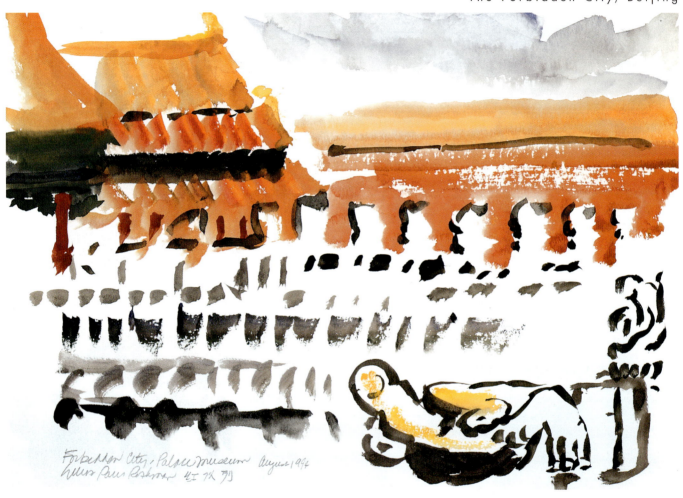

The Summer Palace, Beijing

CHINA

PAGE 8

CANADA CENTRE, VANCOUVER
Canada Centre is an architecture of joy. The billowing sun-filled canvases energize a vigorous working harbor shielded from the Pacific Ocean. The large red cranes are the giraffes of the port with trusses for necks and crossed struts instead of spots.

PAGE 9

SAN DIEGO MARINA, SAN DIEGO
A yacht basin is rhythmic. I felt the pattern of the boats, their masts, the long reflections, and the penetrating sun rays. This challenge to the eye anchors the composition of the painting.

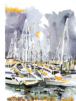
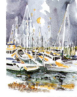
PAGE 10

MARINA, SAN DIEGO
I saw the boats and their tall masts as a symphony in white. I left the paper white to form my masts, which are shaped by the sky and harbor I paint around them. I try to look around or otherwise determine the detail behind each boat, so that I can understand the three-dimensional volumes.

PAGE 11

MARINA FROM HOTEL, SAN DIEGO
This is the painting in which I most successfully merge impression and reality. Standing on my eighth floor balcony, I drew the pier and penciled in each boat. I layered colored washes in order to elicit shapes and shadows. Over time, this process resulted in abstraction.

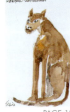
PAGE 12

ABYSSINIAN CAT, MALIBU
I could not resist painting the regal proportions of my friend Juliet's cat. Its long tail, tall body, and expressionless face are timeless.

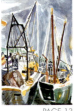
PAGE 13

WELLFLEET FISHING BOATS, CAPE COD
I have spent many weekends over the last thirty five years observing this town and its harbor. I enjoy the powerful fishing boats clustered at the pier. The geometric steel rigging frames the head house and boats beyond. I try to understand what is in shade and what is in shadow, waiting for a glint of sunlight so I can place a streak of cadmium yellow.

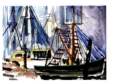
PAGE 14

WELLFLEET HARBOR, CAPE COD
Wellfleet Harbor is intimate. As an artist, I become immersed in its boats. I sit close, looking at the deep green paint thickly applied to their wood surfaces. The rocking boats seemed to be enclosing me.

PAGE 15

NEWCOMB HOLLOW, WELLFLEET
Families blanket this beach with a carnival of colorful umbrellas, towels, beach balls, and bathing suits.

PAGE 16

AUDUBON LANDS, WELLFLEET
Each fall, the tidal lands on Cape Cod Bay turn color. Residences beyond are silhouetted, bearing witness to the heron and other shorebirds that migrate to these rich lands. I simply painted a moment in the cycle.

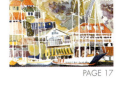
PAGE 17

GUSTAVIA, ST. BARTHÉLEMY
This was the first time I saw that I could define the white masts of boats by painting color around them. Studying the vertical lines of the awnings and window frames sparked my discovery.

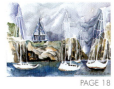
PAGE 18

ANSÉ DE COLUMBIER, ST. BARTHÉLEMY
The intensely bright blue sea and sky contrasted sharply with the boats. Above the sharp rocks, an elegant glass guesthouse emerged, transparent to catch the engaging view. As I painted, the wind shifted, but, luckily, I had already fixed the shape and direction of the boats.

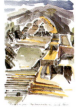
PAGE 19

PLAZA PROMENADE DE LA LUNA, TEOTIHUACÁN
This Mayan promenade is a procession of grand plazas leading to the Temple of the Moon. The place has an ethereal timelessness. Its formal structure is part of the cultural identity in Mexico, repeated time and time again. Painting this scene revealed to me that we had captured its architectural imprint in a new teaching hospital my firm designed for the Universidad Panamericana in Mexico City. Our scheme included a central plaza and patient floors terraced up the hillside.

PAGE 20

PIRAMIDE DEL SOL, TEOTIHUACÁN
The Temple of the Sun is perpendicular to the Temple of the Moon. I was drawn into the receding planes of this imposing edifice by my visceral response to its history of religious passion. Rapidly, I layered my crayon pastel to convey the solidity of the planes.

PAGE 21

PANAMA CITY
Against the mountainside, Panama City's extraordinarily tall and thin buildings felt like stalagmites that had emerged from the natural landscape. From afar, the modern skyscrapers have a pristine, ghostly air that belies the human activity within.

PAGE 22

PANAMA CITY CATHEDRAL
The tight urban square and the ornate white cathedral have power and permanence in an old neighborhood that is undergoing restoration. I used my largest brush, charged with black paint, to convey the strength and mystery of a baroque façade's deep shadows.

PAGE 23

KWADULE, SAN BLAS ISLANDS
Staying in this resort hotel of tiny cottages on a remote island only three hundred feet in diameter, we were surrounded by sky and water. I enjoyed sketching the wonderful lightness of the cottages which seem to float above the water.

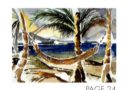

PAGE 24

KWADULE, SAN BLAS ISLANDS
I was almost shocked to find myself painting a scene that could have been a tourist postcard. But, I was caught in the concentric circles of the roots of the palm trees, the palm fronds, and the hammock.

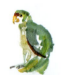

PAGE 25

PARROT, SAN BLAS ISLANDS
As I sat sketching, this brilliant parrot appeared and posed for me for nearly 20 minutes, carefully watching as I painted him. He then flew to a nearby bush. I walked over to finish his beak. We became fast friends.

PAGE 26

PONT MONTEBELLO, PARIS
Sitting on the quay, I could see the three levels of the city: Notre Dame Cathedral and the mansard-roofed buildings, the wall of the quay and the sequence of bridges crossing the Seine, and the river with its tourist boat.

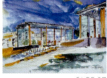

PAGE 27

PARC ANDRE CITROËN, PARIS
In France, I particularly feel the dynamic tension between modernity and architectural history. I wanted to draw a contemporary glass building and capture its transparency. I painted the reflections on the surface of the glass, the interiors, and the buildings you see through these elegantly detailed horticultural greenhouses.

INDEX OF PAINTINGS

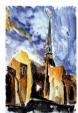

PAGE 28

MONT ST. MICHEL, NORMANDY
I walked up the winding streets to the chapel at the top of the town. The copper steeple and churches, bathed in sunlight, fulfill the religious aspiration of its creators. I would like to paint it every hour of the day and in moonlight…perhaps, someday.

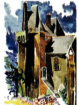

PAGE 29

LE CHÂTEAU DE MONTMURAN, BRITTANY
My wife, Martha, our son Erik, and I attended a joyful Breton wedding. During the brunch reception the day after the wedding, I painted this château. It is rich in color, with strong, evocative shadows. How could I resist!

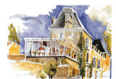

PAGE 30

CANTEGREL, DORDOGNE
Sitting at the swimming pool of the château our family had rented, I intended to paint the house and grounds when I remembered that the owners had commented that their kitchen was too small and insufficient. I was tired of painting "just another château." So, I took their problem as a challenge and designed a contemporary kitchen for them that would enhance the existing building.

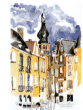

PAGE 31

PLACE DE LA LIBERTÉ, SARLAT, DORDOGNE
I stood at the end of the street in this small village in the Dordogne. I focused on the whimsical turret and the play of shade, shadow, and sunlight in the tight urban space. Finally, I painted the sky beyond the turret brightly in order to draw your eye through the space.

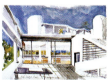

PAGE 32

VILLA SAVOYE, POISSY
Le Corbusier's seminal icon of modern architecture has recently been restored to its original elegance. What surprised me most was the intimacy of the house, which has varied spaces and tremendous sunlight. When I work with highly disciplined architecture, I must first do a lot of drawing, sketching with pencil to capture the proportions. Here, I cannot just record my impressions, but must turn to my training. In this way, I pay homage.

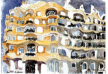

PAGE 33

CASA MILA/LA PEDRERA, BARCELONA
To me, Gaudi's famous apartment building is the crown jewel of the Spanish Modernisme movement. Expressing its organic complexity required two sittings—first to sketch, then to paint. As I worked, I saw new layers of design emerge from the detail hidden in the shadows. Perhaps Gaudi's passion and playfulness allowed me to flow with his intent.

INDEX OF PAINTINGS

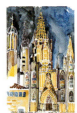
PAGE 34

CATHEDRAL AT BARCELONA
Since it was December, I painted this Gothic Cathedral while sitting in my hotel room, with the French doors opened. (We traded in a large suite for a room with the view.) I sketched and painted day and night. At dusk, the floodlights were turned on so I could continue to work as it grew darker outside. At night, the black sky and artificial light created a sense of drama.

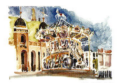
PAGE 35

CAROUSEL, SAN SEBASTIAN
What a delight to find a multi-colored two-story carousel facing the harbor. The gilt sparkled! Imagine the deep-throated tinny music! It is tricky to paint a rotating carousel. I could not complete a horse until it had passed me several times. Momentary stops were godsends.

PAGE 36

GUGGENHEIM MUSEUM, BILBAO
The architecture flowed. My brush moved along with it. It was a cloudy day, but the sun came out periodically, casting shadows on the titanium, reinforcing the undulating forms.

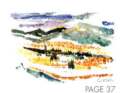
PAGE 37

FEZ
Sketched only with a brush, Fez becomes comprehensible; its colors clarify its parts. The white Jewish cemetery outside the walls, the red roofs of the souk, and the copper clad mosques each form a visual stratum of the city.

PAGE 38

FROM HAMOUD EL MAJOUB'S SHOP, MARRAKECH
Walking around, looking for a site to paint, I found a shop that sold weavings. The owner invited me upstairs where I saw weavers with looms that incorporated the beams of the building, becoming part of its structure. Then my new friend allowed me onto his roof where I painted the small mosque next door from above.

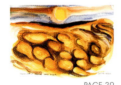
PAGE 39

DUNES AT MERZOUGA
We climbed to the highest dune to see the sunrise in the desert. As I painted the great glowing disc of the morning sun, I could not believe how much contrast there was in the landscape. The sand was fiery red and yellow. The shadows were as black as coal.

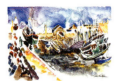
PAGE 40

ESSAOUIRA
This raw boatyard with its massive rough-hewn boat frames and hulls adjoined a plaza to the sea at the portal of the city's souk. As I painted, a young man walked over to me and asked me where I was from. When I replied that I was from Boston, he became very animated, exclaiming "John F. Kennedy!" I asked him: "Why was John F. Kennedy important to you?" He responded that JFK had created the Peace Corps, without which he, and other Moroccans, would not have learned English.

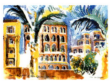

PAGE 41

FROM THE HOTEL IMPERIAL, MARRAKECH
My wife, Martha, and I stayed in a room facing these French Colonial buildings. I was moved by the vibrant colors and the tropical atmosphere. I love the rhythm of the palm fronds interwoven with the sky.

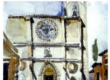

PAGE 42

DUOMO, TODI
This cathedral is perfectly proportioned, with simple detailing that enhances its mass. I touched the planes lightly with a broad sable brush.

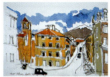

PAGE 43

PIAZZA COLLICOLA, SPOLETO
Our plane returning to Boston was cancelled "because of war." So, we stayed on an extra day and drove to Spoleto, where it rained the next morning. I painted the mountain road we viewed from our hotel room. The winding road energized me as it flowed dynamically past the church, around the curve of the piazza, and onward up the hill.

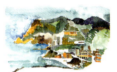

PAGE 44

MONTEROSSA, CINQUE TERRE
Five coastal towns, each defined by a cove, rise up from the waters. The sea and the rocks enfold boats, churches, inns, and houses. As I painted Monterossa, a jewel in the rough, detail evolved so that the many facets of this gem were revealed.

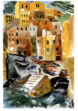

PAGE 45

RIOMAGGIORE, CINQUE TERRE
Fishing boats slide down a ramp to the inlet off the Mediterranean. The dark tunnel underneath the plaza contrasted with the bright red, green, and blue boats. Multi-story earth-toned buildings march up the cliff toward green furrowed fields.

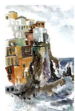

PAGE 46

MANAROLA, CINQUE TERRE
I have never felt anything like the energy and extraordinary drama of the incredible waves crashing high against this town's cliffs. But, somehow, the terraced buildings, some shuttered, some reflecting the white sky in their windows, group together against the remarkable force of the sea.

INDEX OF PAINTINGS

PAGE 47

MOLINO DI CELVIE, ALLERONA, UMBRIA
Grazia's studio is located in a restored barn, now used for painting, writing, living, and exuberant dining. It is perched high, overlooking many valleys. My brush flows with the rolling hills. I absorb detail as the country road cuts through sunlit farms that change color and form even as I paint.

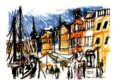

PAGE 48

COPENHAGEN WATERFRONT
I sketched this vibrant canal, with its boats and buildings, using crayon pastel on watercolor paper. Color adhered to the raised texture of the rough paper, but the depressions remained white.

PAGE 49

COPENHAGEN BOAT
The sky, buildings, and bridge along the canal appear to be suspended from two masts.

PAGE 50

TRONDHEIM
Standing at the rail as we were pulling out of Trondheim Harbor, I quickly sketched the docks and outlined the boats in ink. I boldly applied colors on the buildings and docks.

PAGE 51

INDUSTRIAL TRONDHEIM
In the fall, buildings brighten Trondheim's industrial harbor, as the darkened hills obscure it from the setting sun.

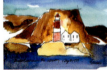

PAGE 52

BUHOLMRASA
Sketching from the deck of a ferry that moved along the coast, I was struck by the simplicity of this lighthouse and the two houses beside it. There is such a beautiful purity to their proportions against the hill behind them.

PAGE 53

THE NORWEGIAN COAST ABOVE THE ARCTIC CIRCLE
Mountains crested in snow give way to farmland foothills, which gently flow into the coastal waters. The sun setting behind the hillside created shadow and subtly glowing valleys. I felt at peace here.

INDEX OF PAINTINGS

PAGE 54

MOUNTAIN CAVES AT STOKKSUND
The sun really casts itself against these hills. There is no tranquility for me here, only tension as the darkening shadows engulf the village and farms.

PAGE 55

SVARTTSEN GLACIER
The sun-strewn glacier melts slowly into the coastal fjord, but its frozen form looks like a snapshot of rapidly moving water. We had walked on the edge, looking down into fissures that are more than 200 feet deep. I was scared to death that I might fall in.

PAGE 56

STOCKHOLM
Elegant empire style buildings in strikingly subtle colors served as a background for the tall white masts of sailing boats moored at the inlet in front of them. I love the contrast between the dignity of the buildings and the playfulness of the boats.

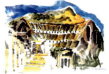

PAGE 57

THE GREAT AMPHITHEATRE AT EPHESUS
I took a position far back so that my view included the great colonnade and processional that led to the amphitheatre. I sketched the vertical outlines of the columns against the sweeping curve of seating book-ended by great stone walls, which I painted with a big brush. Next, I want to paint the new Pittsburgh Pirates Stadium. Its bridge spanning the Allegheny River is a modern processional for hordes of baseball fans.

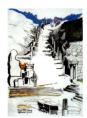

PAGE 58

CURETAS WAY, EPHESUS
Looking from the ancient agora, I sketched the thoroughfare lined with stately Greek statues. The brothel that is across from the agora called to mind the musical comedy *A Funny Thing Happened on the Way to the Forum*. If you have seen it, you can imagine the activity that went on here.

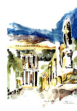

PAGE 59

FROM CURETAS WAY TO THE LIBRARY OF CELSUS
The headless Greek statue, striking a pose in its marble toga, faces downhill to the Library of Celsus with a façade that is a delicate shell of columns and lintels. I was drawn into the softness of the natural landscape beyond. The site of these fields was once an accessible port, but the sea receded long ago.

INDEX OF PAINTINGS

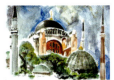
PAGE 60

HAGIA SOPHIA, EXTERIOR, ISTANBUL
When I was a student of architecture, I studied the Hagia Sophia in black and white lantern slides. To actually visit was inspiring. I painted this scene while sitting in the park between the Hagia Sophia and the Blue Mosque. (We returned there at dusk for a *Son et Lumière,* or light show, which is always fun.) I used a broad brush to suggest the arches and the dome. I used thin vertical brush strokes to depict the faceted minarets.

PAGE 61

HAGIA SOPHIA, CLOSE-UP
After finishing my painting of the exterior, I went on to a detail, without leaving my seat. I used a broad brush and minimal pencil work to rapidly capture the curved forms and their shadows.

PAGE 62

HAGIA SOPHIA, INTERIOR SKETCH
Not certain how long I could stay, I used charcoal and crayon pastel to capture the essential qualities of the interior—the light, structure, and color.

PAGE 63

THE BLUE MOSQUE, ISTANBUL
Sketching from the rooftop of our hotel, I was struck by the location of this mosque, perched overlooking the Bosporus, so that arrival by land or water is equally dramatic. From this angle, I could see only five of the six minarets. I used charcoal, crayon pastel, and lots of white paper to express the perfection of the building's placement.

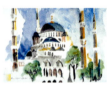
PAGE 64

THE BLUE MOSQUE
Here again, I was painting from the park between the Hagia Sophia and the Blue Mosque. From this vantage point, I saw the layered domes that form the organizing structure of the great mosque, and four of the six minarets. While I was painting, children came over to talk to me. They had been taken out of English class to speak with tourists.

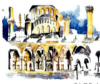
PAGE 65

COURTYARD OF THE BLUE MOSQUE
Past the ritual-washing fountain in the foreground, under the large arched portico, a series of doors open from the great prayer room. The human scale of the mosque is evident as you look from the prayer hall to the grand gardens outside.

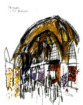
PAGE 66

SPICE MARKET, ISTANBUL
Broadly arched windows under the high vaulted ceiling bring natural light deep into the shops selling gold and into the arcade, laden with baskets of brilliant spices. I captured the crowd with simple strokes of charcoal.

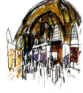
PAGE 67

MOSQUE FROM LATOON
Driving on the road, we passed this multi-colored mosque that I sketched quickly from the car. I loved the purity of the bold hues—the blue of the minaret, the red and yellow dome, and the green and orange walls. In another small mosque that we saw later, a stork had nested between the minaret and the dome.

PAGE 68

LOOKING AT AGA UMAM FROM MURAT II
We toured the Mediterranean coast of Turkey in the gulet where I was sitting as I painted this scene. A rhythm radiates from the steering wheel, directing the eye beyond our boat to the others moored in the cove. The glowing gunwale and underside of the electric blue awning frame the view.

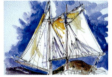
PAGE 69

MURAT II
I sketched our boat from the hillside where I stood looking down to the cove where the gulet was anchored. I used ink and watercolor for my quick impression of sails against the sky.

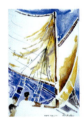
PAGE 70

MURAT II UNDER SAIL
When I caught the moment the sails were unfurled, I was exhilarated! The crew was energized. Blue sky, sunlight, and the shadows from rope ladders and lines define the white sails.

PAGE 71

KANUS HILLSIDE TOMBS
As we motorboated through tall rushes, I sketched these tombs, which are carved into the cliff. Black shadow contrasting with the multi-hued beige stone expresses the proportion and depth of the tombs.

INDEX OF PAINTINGS 91

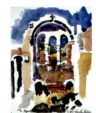

PAGE 72

17TH CENTURY BYZANTINE CHURCH, GEMILER ISLAND
There is poetry in the shell of a Byzantine church. The original arch of the apse remains, framing the grass-covered hill beyond. Rubble in the foreground exposes the three stairs leading to the altar.

PAGE 73

MONASTER ISLE
I waded through these ancient sunken ruins, studying detail in the shade and the deep purple shadows. I painted the subtly exposed sand and the masts beyond the wall.

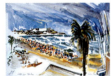

PAGE 74

KALKAN
One of the delights of the coast was our hotel facing Kalkan, a town with several streets of shops edging up the hillside. A variety of form, color, and shadow enlivened Kalkan's church, its port, and its three-storied, portside shopping structure complete with rooftop cafes.

JAFFA FROM TEL-AVIV
This triangular Mediterranean coast connects Tel-Aviv to Jaffa. The multi-colored, umbrella-capped beach contrasts with the more formal historic city beyond. This was a rare day in Israel in which the usually intense sun and shadow gave way to a more even light. I was more than pleased when a colleague compared the sketch to a Raoul Dufy.

PAGE 75

PAGE 76

AL KAZNEH – THE TREASURY BUILDING, PETRA
First, I spent a lot of time just looking. Then it took a while to draw the proportions and detail. The sun moved and ultimately put Al Kazneh into shadow while I was left sitting in harsh sunlight. I was able to complete the painting in about a half hour before I lost the sun entirely.

PAGE 77

NABATAEN TOMBS, PETRA
The valley was still bathed in sunlight when I arrived. I found a cool cave opposite to it. I rejoiced in shadow because the color of the cliffs and the tombs were the same. Shade and shadow defined the forms of columns, capitals, window openings, and cave openings. A shepherd briefly distracted me when he brought his goat into the cave.

INDEX OF PAINTINGS

PAGE 78

PAGODA POND, PEKING UNIVERSITY
I used a somber green monochromatic palette for this painting. I came here to relax from my Chinese studies. This space was tranquil.

PAGE 79

LOTUS POND, PEKING UNIVERSITY
The lotus blossoms have long stems extending to the mud below. The flowers rest on the flat leaves floating on the water. I painted the red arcade beyond to mimic the pink and white lotus flowers.

PAGE 80

THE FORBIDDEN CITY, BEIJING
I painted broadly, using cadmium red for the walls, gray for shadow, and cadmium yellow for the sunlight that bounced off the repetitive man-made forms. The Chinese gardens are carefully shaped, with lots of paving, bordered and edged, embellished with rivulets of water in shallow troughs. I tried to paint the rhythms of the space.

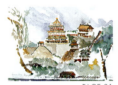
PAGE 81

THE SUMMER PALACE, BEIJING
My class and I bicycled here from our hotel, which was across from the south gate of Peking University. The route was flat; the bicycles had no gears. We rode ancient streets wide enough for bikes and vehicular traffic. I arrived, impatient, and started drawing and painting this vast fabricated lake and mountain. There was everything to draw—water, promenades, arcades, and grand stairs. I wanted to paint everything I saw.

ABOUT THE ARTIST

Elliot Paul Rothman

Elliot Paul Rothman was born in Pittsburgh, Pennsylvania, on April 10, 1935, with his twin brother, Irving N. Rothman. In his teens, he was International President of AZA, the B'nai B'rith Youth Organization, which started him on his travels. In 1958, Elliot earned his Bachelor of Architecture degree from Carnegie Mellon University. He received his master's degree in City Planning in 1960 and his master's degree in City Planning in Urban Design in 1961, both from the Harvard Graduate School of Design. He served an appointment as Associate Professor of Architecture at Harvard from 1967 to 1969. From 1966 to 1969, he was a founding associate of Benjamin Thompson and Associates. In 1969, he and Martha L. Rothman formed Rothman Partners Architects in Boston, Massachusetts, a firm focused on the design of healthcare, academic, and research facilities. In the summer of 1994, he studied the Mandarin language at Stanford University, including a month at Peking University.

Elliot is married to Martha Leibowitz Rothman who received her master's degree in Architecture from the Harvard Graduate School of Design and is a Fellow of the American Institute of Architects. Their three children are Sabine Rothman, Senior Editor at Condé Nast *House and Garden;* Adam Rothman, PhD, Assistant Professor of History at Georgetown University; and Erik Rothman, Director of the Grand Tier Restaurant at the Metropolitan Opera.

His sketches are passionate because he loves the people, the restaurants, and the countries he visits, and he paints what he sees.

ACKNOWLEDGEMENTS

I am indebted to the following people whose encouragement and advice made this book possible: Martha L. Rothman for her constant support and practiced eye, Sabine Rothman and Amy Breedlove for their advice on my text, Donald Miller for his foreword, and Professor Irving N. Rothman for his suggestions. Max Stern, Esq., has always been a supporter. Carolyn Muskat, printmaker, advised me well.

Mitchell T. Rabkin, MD, directed me to Bernie Pucker, Pucker Gallery. Upon his sound advice, I worked with Leslie Feagley, graphic designer, and South China Printing Company who together produced some of Pucker Gallery's elegant art books. Clifford Pfeiffer photographed my work for this book. Jonathan Singer, Singer Editions: Fine Art Digital Printmaking, Boston, has reproduced selected paintings as Iris prints.

My colleagues at Rothman Partners Architects have provided me with enormous encouragement and support over the years. I am grateful to Martha L. Rothman, FAIA, President; Bill Fitzpatrick, AIA; Terry Kenyon, AIA; Carl Sutera; Vera Van Middlesworth; Jay Verspyck, AIA; David Willy, AIA; Gabriel Yaari; Eric Belson; Sheryl Snyder; David Ellis; Valerie Paquin-Gould; and John Hillwig; with deepest appreciation to Deana M. Martin who skillfully managed and reproduced the watercolors the firm used over the years.

I am grateful to my mother, Ida Weber Rothman, who always encouraged me and had a love of life, and to my father, Max, who loved books and who I wish could read this one. My older brother H. David Rothman, who reads no fiction, should enjoy this book.

I am grateful to my teachers and mentors, Raymond Simboli, Carnegie Institute of Technology (now, Carnegie Mellon University), and M. Murray Leibowitz, my late father-in-law, an accomplished watercolorist, who told me there are many colors in everything.

CONCLUSION

I am always fascinated by the power of splashes of color and simple brush strokes to convey reality. When I look at a scene, I see a composition, but when it comes to painting what I see, I invent. I fill in the blanks. I complete what is suggested by the image. What appeals to me about watercolor is that the medium encourages, even requires, an exploration of transparency and abstraction. It allows me to capture light and reveals layered spaces. Painting on site is working with a moving target: the sun shifts, obliterating what I thought was important and eliciting detail in light, shadow, and shade that I did not recognize existed.

I will travel more. I will paint more. I will continue to explore the convergence of vision and suggestion.

— ELLIOT PAUL ROTHMAN

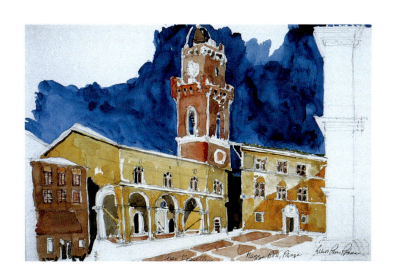